ICONS

FASHION NOW

To stay informed about upcoming TASCHEN titles, please
request our magazine at www.taschen.com/magazine or write to
TASCHEN, Hohenzollernring 53, D-50672 Cologne, Germany,
contact@taschen.com, Fax +49-221-254919. We will be happy
to send you a free copy of our magazine which is filled
with information about all of our books.

Cover: Louis Vuitton by Marc Jacobs. Photography by Craig McDean,
Styling by Edward Enninful. October 1999. Model: Guinevere

Back cover: Levi's. Photography by Steen Sundland,
Styling by James Sleaford. November 2000

Editors: Terry Jones & Susie Rushton
Production director: Matthew Hawker
Fashion director: Edward Enninful
Fashion editors: David Lamb, Erika Kurihara
Production manager: Karen Leong
Managing editor: Eloise Alemany
Sub-editor: Richard Hodkinson
Design co-ordinator: Aya Naito
Assistant: Patrick Waugh
Editorial assistance: Glenn Waldron
Executive director: Tricia Jones

Writers: James Anderson, Lee Carter, Simon Chilvers, Lauren Cochrane, Steve Cook, Will Fairman,
Aimee Farrell, Jo-Ann Furniss, Liz Hancock, Mark Hooper, Jamie Huckbody, Dan Jones, Karen Leong,
Terry Newman, Peter de Potter, Ben Reardon, Marcus Ross, Susie Rushton, Holly Shackleton, Skye
Sherwin, James Sherwood, Josh Sims, David Vascott, Glenn Waldron, Nancy Waters

Photographers: David Armstrong, Peter Ashworth, Christian Badger, Kent Baker, Barnaby & Scott, Orion
Best, Dirk Bikkembergs, Anuschka Blommers, Hamish Brown, Richard Burbridge, Richard Bush, Sergio
Calatroni, Donald Christie, Cricchi & Ferrante, Sean Cunningham, Kevin Davies, Corinne Day, Sophie
Delaporte, Claudio Dell'Olio, David Dorcich, Pete Drinkell, Larry Dunstan, Sean Ellis, Jason Evans, Fabrizio
Ferri, Roberto Franckenberg, Gauthier Gallet, Kate Garner, Giovanni Giannoni, Nathaniel Goldberg, Timothy
Greenfield, Alex Hoerner, Kayt Jones, Matt Jones, Terry Jones, Greg Kadel, Steven Klein, Flo Kolmer, Hiroshi
Kutomi, Karl Lagerfeld, Mark Lebon, Duc Liao, Armin Linke, Cyrus Marshall, Craig McDean, Alasdair McLel-
lan, Michel Momy, Sarah Moon, Stefano Moro, Jeremy Murch, Derrick Nimo, Ellen Nolan, Idesu Ohayo, Marc
Quinn, Terry Richardson, Mischa Richter, Christophe Rihet, Barnaby Roper, Paolo Roversi, Satoshi Saikusa,
Mitchell Sams, Thomas Schenk, Dennis Schoenberg, Niels Schumm, David Sims, Steve Smith, Francesca
Sorrenti, John Spinks, Solve Sundsbo, Takay, Juergen Teller, Tesh, Luke Thomas, Wolfgang Tillmans, Tony
Torres, Nicole Trevillian, Russell Underwood, Max Vadukul, Willy Vanderperre, Anthony Ward, Paul Wetherell,
Robert Wyatt

Editorial co-ordination: Simone Philippi, Cologne
Typesetting: Lioba Waleczek, Cologne
Production co-ordinator: Tina Ciborowius, Cologne

Printed in Italy
ISBN 3-8228-4278-8

FASHION NOW

EDITED BY TERRY JONES & SUSIE RUSHTON

TASCHEN

KÖLN LONDON LOS ANGELES MADRID PARIS TOKYO

PREFACE

"The 21st century didn't start in 2000, it starts now, at a time of uncertainty," says Raf Simons, a designer who continually reflects the Zeitgeist in his work. Each year, more designers are added to the international fashion calendars. Today, Paris, Milan, New York and London are still the fashion show capitals of the world, but many other cities are also creating successful showcase events which give chances to future talents. In 2005, the Hyères competition in the south of France celebrated its 20th anniversary and the International Talent Support in Trieste, Italy staged its fourth contest. More fashion colleges are producing more students who enter an industry which continues to grow every year.

There is also no doubting the importance of emerging economies, where consumers are buying fashion as a way to express newfound success. Global distribution and branding have grown; manufacturing is changing rapidly, with more companies sourcing their suppliers where labour is cheaper. Value for money and credibility are major considerations for any designer today and the fashion-buying customer is better informed than at any other time in history.

So, as consumers of fashion we have an important role to play. Limited edition or purchased from a 'secret' sale, hand-crafted by artisans or produced in multiple – the items we choose to buy and wear are a reflection of our personal ethics and choices. Today we are given so much information about fashion, yet we rarely ask where it's made. It is not enough to know the source of the idea. We should know which animal we are wearing, whether it suffered for our sake and how it was farmed. Several companies are paving the way for an organic movement inside the fashion industry.

In the future, the craft of fashion could be endangered by a market economy focused on price alone. Perhaps counterfeit designer goods fuel the desire to own the real thing, but we need to address how the fakes, too, are manufactured: How old is the person who made that handbag? Did they get a proper meal this week? We have the power to change this in our wallets. How

we buy fashion could force change in the future of consumption and manufacture. This is one of the greatest challenges facing fashion: when fur-wearing editors are targeted by animal rights protesters, this is only the most tabloid-friendly side of the issue.

There are more fashion boutiques, department stores and retail outlets than ever, more people entering fashion institutions that fuel the industry around the world and more TV-time and news coverage that is hungry for a glimpse of glamour. Constantly redefined, fashion captures the moment and reflects a couple of seasons – and these visual impressions make the memory of that day, that month, that year, a living proof that we kept our eyes open, for a split second.

TERRY JONES
Creative Director & Editor-in-Chief, i-D magazine

PHOTOGRAPHY BY HIROSHI KUTOMI, STYLING BY YOSHIYUKI SHIMAZU. AUGUST 2002

A Bathing Ape has thrived on exclusivity since its conception in 1993. Hip-hop inspired baggies, urban camouflage prints and playful simian motifs are all signatures for the label, which is affectionately known to its disciples as BAPE. The longevity of the brand is impressive: in the ephemeral world of streetwear, 12 years is a long time. The secret to the success of A Bathing Ape, the brainchild of Japanese designer Nigo, is ruthlessly limited editions and an almost mythological inaccessibility. (Outside of Japan, the brand is only available in two direct-management stores in the UK and, since 2005, the US.) Nigo studied fashion at the Bunka Fashion College in 1988 and the young entrepreneur now has his jewel-adorned fingers in a variety of pies, including a record label (which grew out of his collaboration with James Lavelle, founder of Mo' Wax), art gallery, café/restaurant, hair salon, toy division (think 'Planet of the Apes') and TV show. Perhaps it is through the continual diversification of the brand that Nigo has managed to retain BAPE's underground mystique, despite advertising tie-ins with multinationals such as Pepsi, Sony and Adidas. The name A Bathing Ape derives from a Japanese expression meaning 'to bathe in lukewarm water', and is intended as a comment on the sheltered and shallow nature of Japanese youth culture. The irony, however, is apparently lost on the swelling army of BAPE followers, whose uniform is head-to-toe 'APECAMO'. And with a clutch of A-list clients such as The Beastie Boys, Futura 2000 and Pharrell Williams on his side, the Ape looks set for worldwide domination, King Kong style. NANCY WATERS

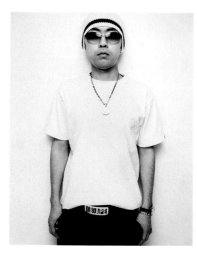

"Ape shall never kill Ape"

NIGO / PORTRAIT COURTESY OF NIGO

A BATHING APE

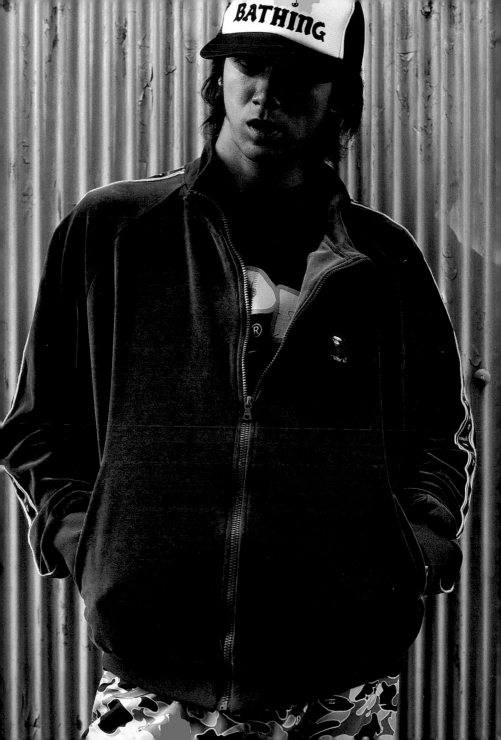

PHOTOGRAPHY BY CHRISTOPHE RIHET, STYLING BY HAVANA LAFFITTE. MAY 2002

Miguel Adrover's themed collections, which are often inspired by the people and cultures he sees in New York and when travelling, are unique for their authentic interpretation of everyday dress. Born in a small village in Majorca in 1965, Adrover moved to New York in 1991 and began producing a line of customised T-shirts with his friend Douglas Hobbs and in 1995, the pair opened a boutique, Horn. Adrover is entirely self-taught; friends and supporters, not tutors and examinations, have shaped his career. In 1999 the first Miguel Adrover collection, 'Manaus-Chiapas-NYC' was shown at New York Fashion Week. His debut, which showed deconstructed thrift-store clothes alongside virtuoso tailoring, was met with equal amounts of bemusement and praise. Adrover's recycled pieces have always impressed, and for spring/summer 2001, he fashioned a sharp town coat from mattress ticking that had been thrown out on the street by Quentin Crisp – it is now part of the Metropolitan Museum of Art's fashion collection. In June 2000 he won the CFDA award for Best New Designer and the Pegasus Apparel Group began financing his label, a partnership that lasted until autumn 2001, when the post-September 11 mood worked against his multicultural themes and political assertions. After splitting from Pegasus, Adrover re-built his reputation and studio and returned to the catwalk for spring/summer 2003 with a beautifully-tailored collection entitled 'Citizen of the World'. Again, it paid tribute to the cosmopolitan mix of nationalities found in New York; the show climaxed with a pale blue dress fashioned from a United Nations flag. In 2005, Adrover moved his studio back to Spain. Always diverse in its inspiration, challenging and immaculately stitched, Adrover's clothing has paved the way for a new generation of young and experimental designers who have adopted New York as their home.

SUSIE RUSHTON

"I use clothing as a venue to exhibit my interpretations and expressions"

PORTRAIT COURTESY OF MIGUEL ADROVER

MIGUEL ADROVER

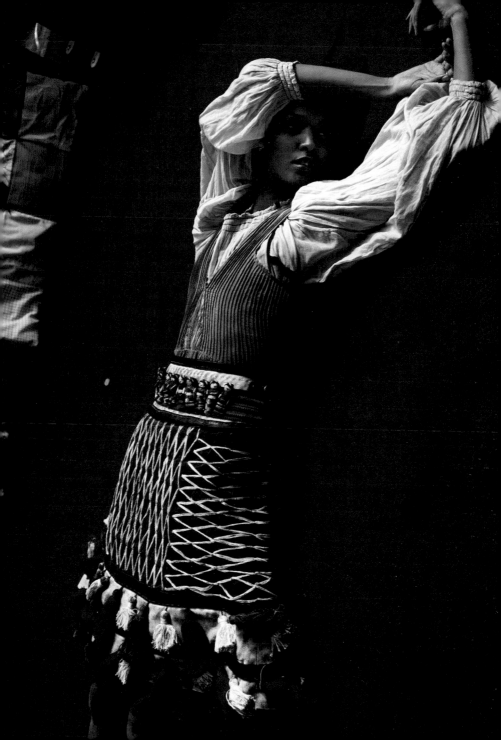

PHOTOGRAPHY BY DUC LIAO, STYLING BY KANAKO B KOGA. MARCH 2002

AF Vandevorst, the Belgian design duo of An Vandevorst (born 1968) and Filip Arickx (born 1971), view fashion as nothing less than a way to communicate the inner workings of the mind. The husband-and-wife design team met in 1987 at the Royal Academy in Antwerp. On graduating, Vandevorst worked as assistant to Dries Van Noten. Meanwhile Arickx, who worked for Dirk Bikkembergs for three years as a teenager, completed military service after leaving the Academy, and then worked as a freelance designer and stylist. Together they established their own label in 1997, and presented their first collection in Paris for autumn/winter 1998. The label quickly came to the attention of both the fashion press and establishment; after only their second collection they were awarded Paris Fashion Week's Venus de la Mode award for 'Le Futur Grand Créateur', a prestigious prize for newcomers. For the spring/summer and autumn/winter 2000 seasons the pair were invited to design the Ruffo Research collection, an opportunity periodically offered to young designers by the Italian leather house Ruffo. AF Vandevorst clothes convey a slouchy confidence, and a version of femininity that evokes a sexy yet intellectual cool. Traditional clothing (horse riding equipment, kimonos, frock coats) is often referenced, reworked and refined until it sits slightly left-of-centre; a medical-style red cross is their enduring symbol. For collection themes, they often favour the unexpected, as for autumn/winter 2003, when honey bees provided inspiration. Following no set colour palette, AF Vandevorst stray from muted tones into brights. Recently the label has expanded to encompass footwear, accessories and lingerie, and they continue to present catwalk shows during the Paris collections. LIZ HANCOCK

"Fashion is a language"

AN VANDEVORST AND FILIP ARICKX
PORTRAIT COURTESY OF AN VANDEVORST AND FILIP ARICKX

AF VANDEVORST

PHOTOGRAPHY BY MATT JONES, STYLING BY CATHY DIXON. SEPTEMBER 2001. MODEL: LISA MARIE

From Soho to Vegas, Agent Provocateur is first stop for connoisseurs of sexy lingerie. Since founding their company in 1994, AP inventors Serena Rees and Joseph Corre have transformed the underwear market with their seductive and nostalgic designs. It's hot tabloid news when a celebutant goes shopping in one of their boudoir-esque stores, not least because purchases might include crotchless panties, sequin pasties or fluffy high-heeled slippers. We will probably never find out, however, because the AP shopgirl, cute as a cupcake in her baby pink button-up shirtdress (designed by Vivienne Westwood, who happens to be Joseph's mum) is sworn never to reveal her VIP dressing room secrets. Married couple Rees (born 1968) and Corre (born 1969) design an entire range of fit-for-a-glamour-goddess lingerie plus accessories, jewellery, lipsmacking leather pieces, shoes and stockings. An award-winning perfume made its debut in 2000, closely followed by a wealth of bathroom and bedroom fancies – candles, lotions and even a nipple balm. Famed for the racy window displays in their boutiques, and an equally welcoming retail website, Agent Provocateur's passion is evident in everything they do. And the Provocateur product is not just on display in the most interesting bedrooms: it was included in the V&A's Cutting Edge exhibition in 1997 and also 'The Inside Out' show at The Design Museum in 2000. Whether it's their adult-rated commercials, music projects such as their well-received CD, Peep Show, of 2004, or collaborations with Marks & Spencer and Tate Modern, AP is always about sexual liberation conducted, of course, all in the best possible taste. TERRY NEWMAN

"Girls, girls, girls: sex kittens, sex bombs, seductresses, naughty girls, secretaries, schoolgirls and Kate Moss"

SERENA REES AND JOSEPH CORRE / PORTRAIT BY TESH

AGENT PROVOCATEUR

PHOTOGRAPHY BY MAX VADUKUL, STYLING BY NICOLETTA SANTORO. JUNE 2001. MODEL: ELEONORA

Azzedine Alaïa's place in the design hall of fame is guaranteed – his signature being the second skin that he creates when challenging the boundaries of flesh and fabric. Alaïa was born in Tunisia in the '40s to wheat-farming parents. A French friend of his mother's fed Alaïa's instinctive creativity with copies of Vogue and lied about his age to get him into the local Ecole des Beaux-Arts to study sculpture – a discipline in which he didn't excel, but that he would put to good use in the future. After spotting an ad for a vacancy at a dressmaker's, Alaïa's sister taught him to sew and he started making copies of couture dresses for neighbours. Soon afterwards, he went to Paris to work for Christian Dior, but managed only five days of sewing labels before being fired. Alaïa moved to Guy Laroche, where for two seasons he learned his craft while earning his keep as housekeeper to the Marquise de Mazan. In 1960, the Blegiers family snapped up Alaïa, and for the next five years he was both housekeeper and dressmaker to the Countess and her friends, mixing with glamorous Paris society; a clientele that followed him when he started out on his own. His first ready-to-wear collection for Charles Jourdan in the '70s was not well received, but eventually fashion editors tuned into Alaïa's modern elegance – something that would eventually come to define body conscious aesthetics a decade later. Worldwide success followed with exhibitions, awards, supermodel disciples and the power to command an audience outside of the catwalk schedule: Alaïa shows when he wants, regardless of the round of timetabled international fashion weeks, and editors never miss it. In 1998, he published a book of photographs of his creations, entitled 'Alaïa' and in 2000, he joined forces with the Prada Group. The same year, he was honoured with a solo exhibition at the New York Guggenheim. In October 2004 he opened his very own hotel (5 rue de Moussy) adjoining the Alaïa headquarters in Paris. JAMIE HUCKBODY

"Perfection is never achieved, so you need to go on working"

PORTRAIT BY MAX VADUKUL

AZZEDINE ALAÏA

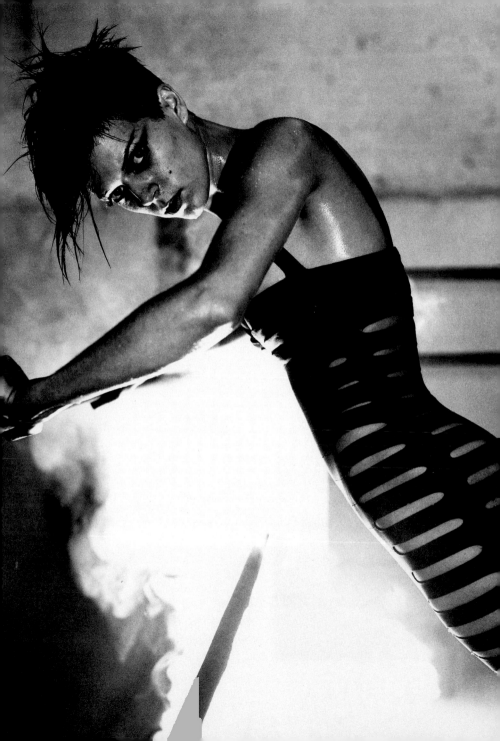

PHOTOGRAPHY COURTESY OF APC. AUTUMN/WINTER 2002

You'll never see an APC creation waltzing down a catwalk accessorised with a pair of horns. Instead, the subtle fashion brand has a coded elegance that attracts discerning customers drawn to APC's perfect jeans, shrunken blazers, sunglasses and radical T-shirts. In addition to clothing, there's the treasure trove of APC 'things' on offer each season: guitar plectrums, books (such as their edition of Charles Anastase illustrations), shaving oil, candles, olive oil. And it's all the brainchild of Jean Touitou, who was born in Tunis in 1951 and graduated from the Sorbonne in Paris with a history degree and no intention whatsoever of becoming a fashion designer. It was entirely by accident that he landed his first job with Kenzo, which was followed by gigs at agnès b. and Irié before finally deciding to go his own way in 1987 with the launch of APC (Atelier de Production et de Création). Touitou began with menswear, and quickly followed with a womenswear collection debuting the year after. In 1991 the first APC shop opened in Japan and today the company has stores in Hong Kong, New York, Berlin and Paris, plus a comprehensive online service. Collaboration is important to Touitou and over the years he has partnered Margiela, Martine Sitbon, Eley Kishimoto and Gimme 5 for innovative limited edition projects. Jessica Ogden designs a childrenswear line and, since 2004, also the mini Madras collection of beachwear inspired by Indian textiles. The company also has a music division; Marc Jacobs and Sofia Coppola, among others, have put their names to compilations on the APC music label and dance albums, punk-jazz and French-Arabic CDs have all been released to further express the brand's originality. TERRY NEWMAN

"What inspires me is whatever helps you to get away from mental pollution"

JEAN TOUITOU / PORTRAIT BY TERRY JONES

APC

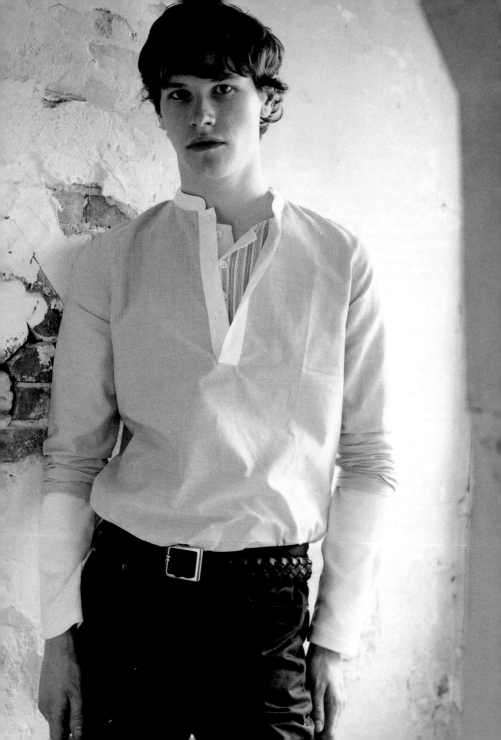

PHOTOGRAPHY BY TESH, STYLING BY EDWARD ENNINFUL. FEBRUARY 2002. MODEL: GISELE

Now in his fifth decade working in fashion, Giorgio Armani is more than just a designer – he's an institution, an icon and a multinational, billion-dollar brand. Armani the man was born in 1934 in Piacenza, northern Italy. He spent his formative years not in fashion but studying medicine at university and completing his national service. After working as a buyer for Milanese department store La Rinascente, he scored his first break in 1964, when he was hired by Nino Cerruti to design a menswear line, Hitman. Several years as a successful freelance designer followed, but it was in 1975 that the Giorgio Armani label was set up, with the help of his then business partner Sergio Galeotti. Armani's signature 'unstructured' jackets for both men and women (a womenswear line was established in 1976), knocked the stuffing out of traditional tailoring and from the late '70s, his clothes became a uniform for the upwardly mobile. Men loved his relaxed suits and muted colour palette of neutral beiges and greys. His designs for women, meanwhile, were admired for an androgynous and modern elegance. Richard Gere's suits in 'American Gigolo' (1980) were a landmark for the designer, as was the cover of Time magazine in 1982. The brand now encompasses six major fashion lines and has diversified into bedlinen, chocolates and even hotels. Armani has won countless awards, including an Honorary Doctorate from the RCA in 1991; from 2000 his designs have been exhibited in a major retrospective show that has travelled worldwide. Armani has also picked up a dedicated Hollywood following, and January 2005 saw the launch in Paris of 'Giorgio Armani Privé', an haute couture-like collection. LAUREN COCHRANE

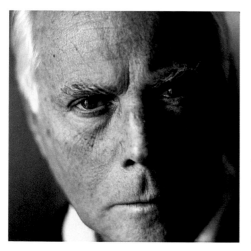

"I have realised over time that I have to take responsibility for my actions and beliefs"

PORTRAIT BY ARMIN LINKE

GIORGIO ARMANI

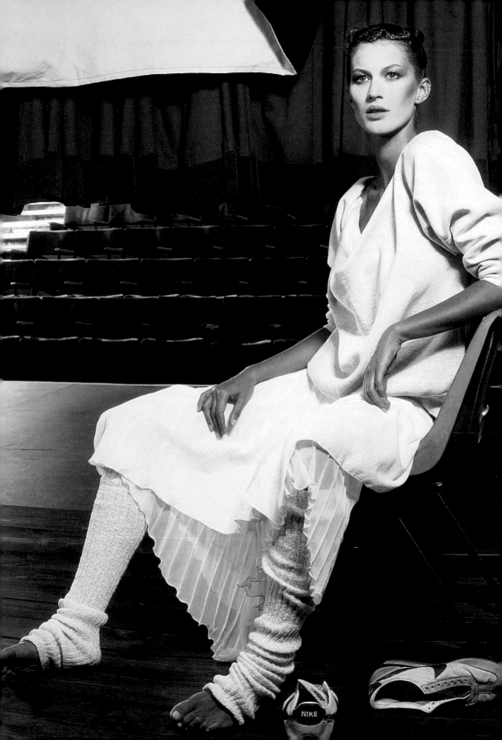

PHOTOGRAPHY BY TESH, STYLING BY EDWARD ENNINFUL. OCTOBER 2001. MODEL: BRIDGET HALL

When the great Cristobal Balenciaga closed the doors of his couture house in 1968 he lamented, "There is no one left worth dressing." For decades the house lay dormant until 26-year-old Frenchman Nicolas Ghesquière was appointed creative director of Balenciaga in 1997 after the departure of Josephus Thimister. Since 1995, Ghesquière had quietly freelanced for Balenciaga's licences. Three years later, Ghesquière won the Vogue/VH1 Avant Garde Designer of the Year Award, followed by the CFDA womenswear Designer of the Year title in 2001. Suzy Menkes of The International Herald Tribune called him "the most intriguing and original designer of his generation". Though relatively unknown when he was appointed to Balenciaga, Ghesquière's is a life in fashion. He won work placements at agnès b. and Corinne Cobson while still at school in Loudon, central France. At 19, he became an assistant designer to Gaultier and then Mugler, before a brief tenure as head designer at Trussardi. But his great achievement has been his revival of Balenciaga. His green silk crop combat pants for spring/summer 2002 were the most copied garment of the season and Neoprene mini skirts and dresses for spring/summer 2003 kept Balenciaga on the edge, creatively and commercially. In 2002 a menswear line was launched, a year after the house of Balenciaga was bought by the Gucci Group. For autumn/winter 2005 he showed A-line leather dresses trimmed with pale ostrich feathers and sleek tailoring fitted with chrome fastenings. Former Gucci CEO Domenico De Sole has said: "Balenciaga has one fantastic asset. He's called Nicolas Ghesquière". JAMES SHERWOOD

"The history of the house is incredible, which means I can work with a lot of freedom"

NICOLAS GHESQUIÈRE / PORTRAIT BY DAVID SIMS

BALENCIAGA

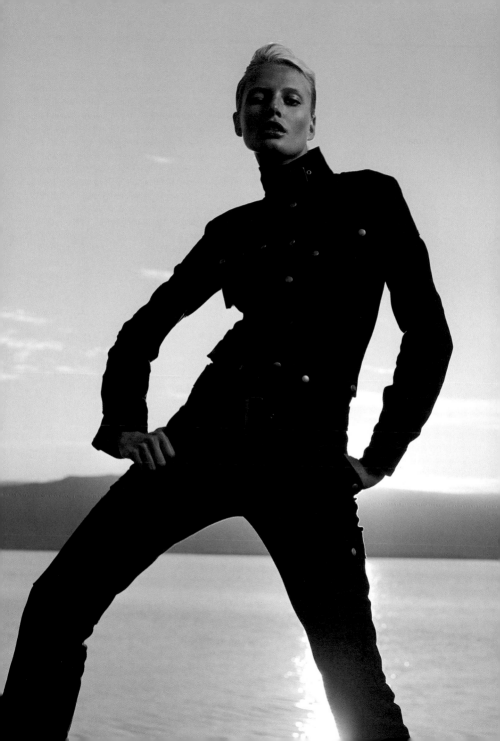

PHOTOGRAPHY BY NICOLE TREVILLIAN, STYLING BY DAVID LAMB. FEBRUARY 2002

With his own Milan-based label, a host of celebrity clients and a stint as an MTV presenter, Neil Barrett has come a long way from his Devonshire roots. Known for clothes that focus on detail and cut, Barrett's is an approach underpinned by an extensive knowledge of fabric production, which he employs to rejuvenate classic designs. With subdued colours and restrained tailoring, Barrett's menswear range is avowedly masculine – a factor that has contributed to its widespread appeal. Born in 1965, Barrett graduated in 1986 from Central Saint Martins, and received an MA from the Royal College of Art in 1989. Within a year he was made senior menswear designer at Gucci in Florence, where he worked until 1994 – a period in which the brand underwent an important revival, both creatively and financially. Success at Gucci enabled Barrett to approach Prada with a proposal for a menswear line. Prada accepted his offer and he began work as the company's menswear design director. He remained at Prada until 1998, when he launched his first self-named menswear collection. This was an immediate success that was snapped up by over 100 designer stores across the world. The following year Barrett set up White, his own Prada-produced label, which was invited to open the Pitti Immagine Uomo Fair in 2000 where he also introduced his first womenswear collection. The next few years saw Barrett sign a footwear deal with Puma and in 2004 he redesigned the Italian national football team's strip for the European Championship – an honour for a non-Italian and a testament to the worldwide success of his label. DAVID VASCOTT

"It's good to listen, to discuss, but it has to be your own conviction that makes each decision"

PORTRAIT BY ARMIN LINKE

NEIL BARRETT

PHOTOGRAPHY BY CYRUS MARSHALL, STYLING BY CARISA GLUCKSMAN. APRIL 2002

Born in Columbus, Ohio in 1963, a love of self-expression led John Bartlett to invest in vintage military uniforms, procured from neighbourhood Salvation Army stores. These, teamed with an Adam Ant hairstyle and more eyeliner than Dusty Springfield, thwarted his parents' dream of an investment banking future. And despite the distractions of a Harvard University degree in sociology, Bartlett continued to remain true to his obsessions: clubbing and clothing. Moving to London in 1985, he blew his postgraduate fees in King's Road boutiques, stockpiling outfits for the nightclub Taboo. Back in New York a year later, he undertook evening classes at the Fashion Institute of Technology and finally began learning the intricacies of pattern cutting, combining 'proper' techniques with an instinctive flair. Since the late 1980s, Bartlett has become an increasingly formidable force within the industry. He has held positions as menswear designer for Williwear (incredibly, his first job in 1988); menswear Design Director for Ronaldus Shamask; and, from 1998, as Creative Director for Byblos men's and womenswear. With an outlook that skilfully blends creativity with commercial nous, his eponymous label (founded in 1992) has far surpassed its origins in a West Village walk-up; prestigious awards have been bestowed from the likes of Woolmark and the CFDA (Bartlett was the first menswear designer to win its Perry Ellis Award for New Fashion Talent in 1994). In 2000, Bartlett showed his menswear collection for the first time in Italy as a guest of Pitti Immagine Uomo Fair. In 2001 he brought operations back to New York, focusing exclusively on menswear and launching a diffusion range, John Bartlett Uniform, in 2002.

"Growing up gay in Middle America provided a very specific twisted perspective on how clothing can inform and educate"

PORTRAIT COURTESY OF JOHN BARTLETT

JOHN BARTLETT

PHOTOGRAPHY BY SOPHIE DELAPORTE, STYLING BY GIANNIE COUJI. JULY 2004. MODEL: DIANA DONDOE

When Antonio Berardi comissioned his own perfume as a gift to the audience of his 1994 graduation show, it was clear that this was a fashion student with his sights set sky-high. Born in Grantham, UK, in 1968 to Sicilian parents, Berardi credits many design influences to his Italian roots: hourglass figures are his preferred silhouette and he constantly references Catholic symbolism in collections. A job assisting at John Galliano's studio was a solid training ground while he tried to land a place on the BA fashion course at Central Saint Martins; he was finally accepted onto the course in 1990, after his third application. On leaving college, Berardi quickly rose to fame. His degree collection was bought by Liberty and A La Mode in London, Kylie Minogue modelled for his first official show and Philip Treacy and Manolo Blahnik designed accessories. His signature tailored leather trouser suits and sheer chiffon dresses, often embellished with crystals, punchwork or hand-painted flowers, were shown at spectacular themed presentations. By his fourth collection, for autumn/winter 1997, Berardi had found an Italian backer, Givuesse. In 1999 he moved from the London catwalks to Milan. The following year, Extè appointed Berardi head designer and also began to produce his eponymous line. The partnership ended in autumn 2001 and a new Italian backer, Gibo, stepped in to provide Berardi with financial security. He now has a second line, called 2die4, and myriad stockists around the world, including a substantial client list in Russia. Berardi is a designer fascinated by technical achievement and his showstopping pieces – a coat decorated with dozens of tiny lightbulbs that illuminate to form a crucifix, say – support his view that, in the pursuit of glamour, nothing is impossible.

SUSIE RUSHTON

"My work is not for shy, retiring wall-flowers, it's about tits and arse"

PORTRAIT COURTESY BY STEFANO GUINDANI

ANTONIO BERARDI

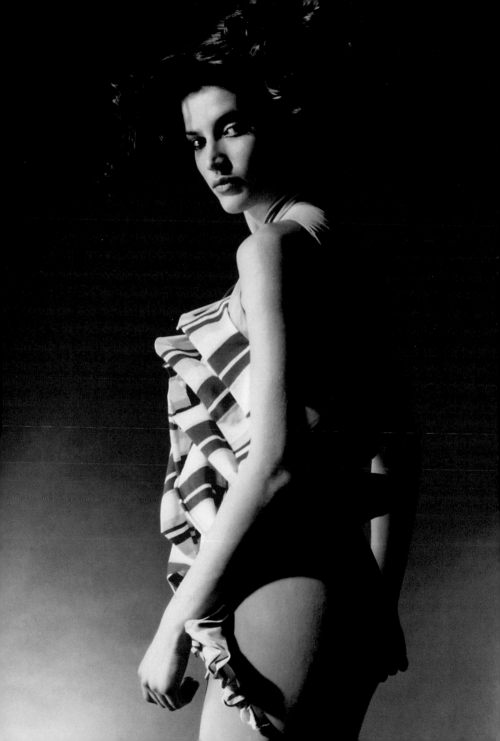

PHOTOGRAPHY BY MANUEL VASON, STYLING BY CHRISTINE FORTUNE. OCTOBER 2004. MODEL: NADJA AUERMANN

The work of Dirk Bikkembergs is pure muscle. Part of the original 'Antwerp Six' he transfers the codes and nuances of sportswear to a sharp signature style that lies somewhere between the ideas of strength, health and durability. The German-born designer (born 1959) graduated from Antwerp's Royal Academy in 1982 before working for a variety of Belgian fashion companies, picking up the prestigious Golden Spindle Award for Best Young Designer in 1985. The son of army parents, Bikkembergs often makes references to the military in his work with tightly structured pieces and the odd fetish-like leather detail. Launching his first collection of men's shoes in 1986, the designer set out a strict design formula that included his trademark double stitch (his clothing not only appears robust but is actually physically strong). In 1987 he introduced his menswear line, with the focus on knitwear, and the following year presented his first full collection menswear in Paris. By 1993 his reputation had strengthened further and he adapted his perfectly masculine aesthetic for the first Dirk Bikkembergs womenswear line, which proposed tailored capes and reefer jackets. In the years since, numerous additional lines and projects have been introduced, including the White Labels for men and women and the Red Label Bikkembergs Jeans collection in 2000. In the same year the designer also picked up the Moet et Chandon Espirit du Siècle award. In 2003, Bikkembergs became the official designer to Italian football giants Internationale, tightly trussing thighs with his unique translation of sportswear. Bikkembergs continues to infuse a physical energy into his clothes, a comforting muscle-bound heaviness, sharp detail, durability and a hard-nosed eroticism. DAN JONES

"I'm inspired by youth, health, sport, raw energy"

PORTRAIT COURTESY OF DIRK BIKKEMBERGS

DIRK BIKKEMBERGS

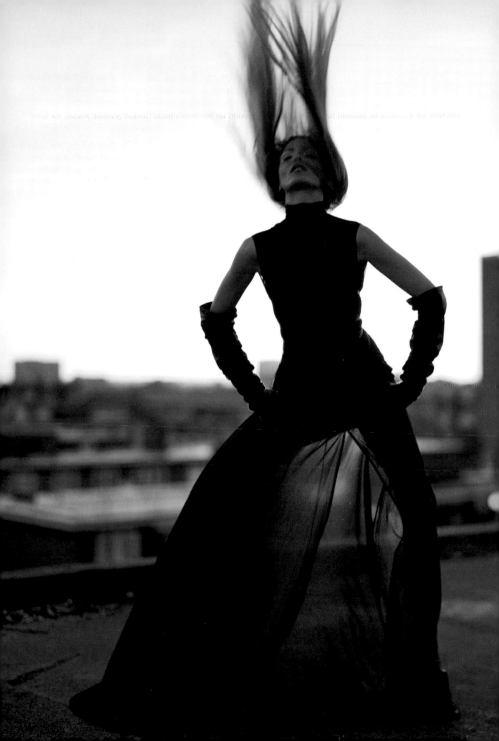

Manolo Blahnik was wrong when he said "shoes help transform a woman". He should have said "my shoes transform a woman." Born on the Canary Islands in 1942 to a Spanish mother and a Czech father, Blahnik studied law and literature in Geneva, moving onto art in Paris in the mid-'60s, and set design in London soon after. Always in the right place at the right time, he met Diana Vreeland on a visit to New York in 1970. Seeing his sketches of shoes, the influential American Vogue editor advised him to pursue a career in footwear. To the delight of women ever since – and in particular one Carrie Bradshaw, who made him a household name 30 years later – Blahnik did so. Back in London, he learnt his craft by visiting shoe factories and studying each stage of footwear alchemy (he is still very much hands-on, and makes shoe himself). Within a year, Blahnik was making the delicate, resolutely feminine shoes he has become famous for. In 1968 he opened his first boutique in London's Chelsea. It attracted such fans as Bianca Jagger, Jerry Hall and Marie Helvin. Very much part of this glamorous set, in 1974 Blahnik was the first man featured on the cover of British Vogue. He started collaborating with young designers in the '70s – first, with Ossie Clark in 1972. Names as diverse as Calvin Klein, John Galliano and Proenza Schouler have all had their footwear created by him. Blahnik has won countless awards, including an Honorary Doctorate from the RCA in 2001 and the first ever Silver Slipper Award given to a shoe designer in 1999. To add to his design icon status, London's Design Museum staged the first Blahnik retrospective in 2003. LAUREN COCHRANE

"I have a passion for work"

PORTRAIT BY KEVIN DAVIES

MANOLO BLAHNIK

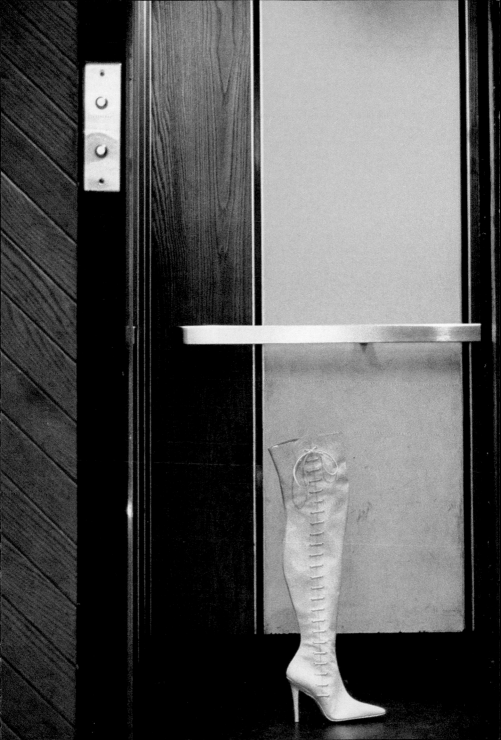

Whether Bless counts as a fashion label at all is a moot point. Preferring to describe their venture as "a project that presents ideal and artistic values to the public via products", Desirée Heiss (born 1971) and Ines Kaag (born 1970) formed Bless in 1995, positioning themselves as a collaborative experiment in fashion. The business is spilt between two European capitals: Heiss, who graduated from the University of Applied Arts in Vienna in 1994, is based in Paris, while Kaag, who graduated from the University of Arts and Design in Hanover in 1995, is based in Berlin. The two met by chance when their work was shown adjacently at a Paris design competition. The Bless modus operandi is to re-invent existing objects to produce new garments and accessories which are released in quarterly limited editions and are available through subscription. Their work has included fur wigs for Martin Margiela's autumn/winter 1997 collection, customisable trainers for Jean Colonna, and the creation of 'Human-Interior-Wear' for Levi's. While these all function as wearable garments, many of their products cross entirely into the realm of art. 'Embroidered Flowers', for instance, is a series of photographic prints, while their 'Hairbrush Beauty-Product' (a brush with human hair for bristles) is closer to the work of Joseph Beuys or Marcel Duchamp than any fashion designer. Consequently, when the 'Bless Shop' goes on tour, it visits Europe's alternative galleries, rather than department stores. Heiss and Kaag's success is in providing a unique comment on fashion that can also (usually) be worn. MARK HOOPER

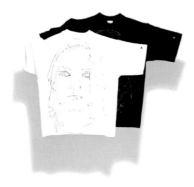

"We don't design things we would not need if we were the client"

DESIRÉE HEISS AND INES KAAG / PHOTOGRAPH COURTESY OF BLESS

BLESS

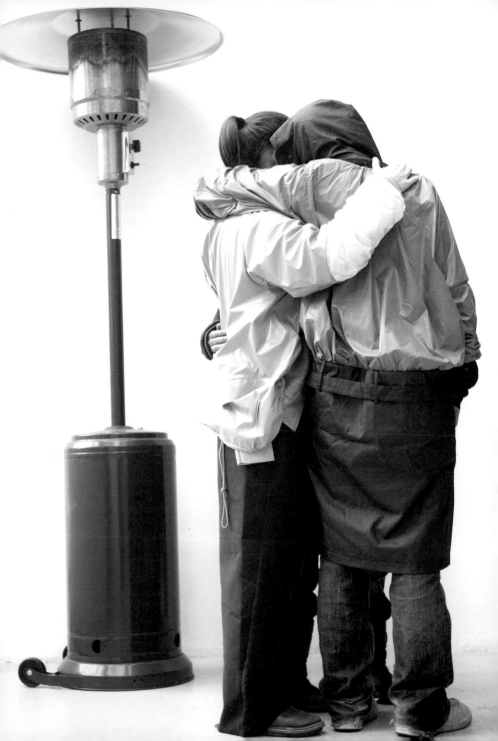

PHOTOGRAPHY BY PAUL WETHERELL, STYLING BY SORAYA DAYANI. NOVEMBER 2000

Véronique Branquinho doesn't design attention-seeking clothes. Instead, she prefers to create beautiful garments whose desirability is only enhanced by their functionality. Born in 1973 in the Belgian town of Vilvoorde, Branquinho first studied modern languages and then painting, switching to fashion in 1991 at Antwerp's Royal Academy. She graduated in 1995 and began working for some of Belgium's top commercial labels, but always maintained the desire to create her own line. In October 1997 she presented her first fashion collection at an art gallery in Paris. The show drew the attention of the international press and retailers, allowing her to launch, the following season, onto the official fashion calendar. With a discreet sexuality, her clothing uses a muted palette of colours, mannish tailoring and street references in order to temper the femininity of fabrics such as lace, satin and chiffon. Through her garments, she acknowledges the duality of female fashion identity – a constant seesaw between the masculine and feminine, the girl and the woman. For spring/summer 2005, she was inspired by '70s soft-core porn icon Emmanuelle; the long-line skirts and tailoring that actually appeared on Branquinho's runway however were as subtle as ever. Now central to Belgium's formidable fashion community, Branquinho has exhibited at Florence's Biennale Della Moda, Colette in Paris, New York's Fashion Institute of Technology and Walter Van Beirendonck's 2001 "Landed" exhibition in Antwerp. She received the 1998 VH1 Fashion Award for best new designer, the Moët Fashion Award in 2000, and was chosen by Ruffo Research to create their spring/summer and autumn/winter 1999 collections. In 2003, Branquinho launched her first men's collection in Paris, and opened her first flagship store in Antwerp. LIZ HANCOCK

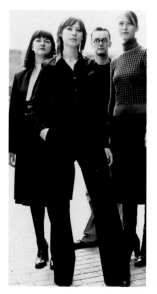

"I'm inspired by the inner complexity of a woman"

PORTRAIT BY WILLY VANDERPERRE

VÉRONIQUE BRANQUINHO

PHOTOGRAPHY BY RUSSELL UNDERWOOD, STYLING BY DAVID LAMB. SEPTEMBER 2002

Yorkshire-born Christopher Bailey has become something of a household name, thanks to his sterling work as creative director of Burberry, the British company he joined back in 2001. Yet Bailey (born 1971) is far from an overnight sensation, having previously notched up impressive fashion credentials. On completing a Master's degree at the Royal College of Art in London (1994), Bailey worked in New York for Donna Karan from 1994 to 1996, before being hired by Tom Ford as a senior designer of womenswear at Gucci in Milan, from 1996 to 2001. At Burberry, Bailey is responsible for the direction of all product lines, as well as the definition of the company's overall image and seasonal advertising concepts. His flagship collection is the forward-thinking Prorsum lines for men and women that are presented in Milan to consistently rave reviews and from which he has banished almost all trace of the hallmark Burberry check. An unerring eye for clear, bright colour and subtle innovations in tailoring have emerged as key to both menswear and womenswear collections. Developing his codes gradually, Bailey is concerned with longevity, rather than resting on the corporate laurels. Nonetheless, the designs he has produced respectfully acknowledge the Burberry heritage (the company was founded in 1856). For example, he has made no secret of his admiration for their classic gabardine trenchcoat, which for autumn/winter 2004 he abbreviated into capes, for both men and women. Renowned for his hands-on approach to design and an enthusiasm for the details, he continues to propel the brand into the 21st century with his customary passion, enthusiasm and cheerful demeanour. In acknowledgement of his many successes, the Royal College of Art awarded Bailey an Honorary Fellowship in 2003.

JAMES ANDERSON

"I'm a very down-to-earth designer"

CHRISTOPHER BAILEY / PORTRAIT COURTESY OF CHRISTOPHER BAILEY

BURBERRY

PHOTOGRAPHY BY ALASDAIR MCLELLAN, STYLING BY SIMON FOXTON. JULY 2001

Joe Casely-Hayford has remained true to the aims he established at the outset of his career thirty years ago – to create clothing that simultaneously subverts tradition, yet is always infused with principles of sound craftsmanship. His signature – classic English fabrics and ingenious darting, pleating and layering – might be defined as 'deconstructed tailoring'. Born in Kent in 1956, Casely-Hayford commenced his design journey in 1974, first by training in London's Savile Row, then attending the Tailor and Cutter Academy. In 1975 he enrolled at Central Saint Martins College, graduating in 1979, followed by a one-year history of art course at London's Institute of Contemporary Art (ICA). His design for men and women combines this knowledge of fashion, tailoring, art and social history with an appreciation of youth culture. Although it was not until 1991 that Casely-Hayford made his London Fashion Week debut, he had already enjoyed considerable related success – working as a styling consultant for Island Records, creating clothing for The Clash in 1984, and being nominated for the Designer of The Year Award in 1989. Throughout the '90s his reputation was further enhanced when he dressed the likes of Lou Reed, Bobby Gillespie, Suede and U2. Casely-Hayford was also one of the first designers to co-operate with high street fashion chains such as Topshop, for whom he designed a sell-out womenswear range in 1993. His work has consistently ventured beyond the catwalk to be featured in prestigious exhibitions such as the 'Rock Style' show at the Metropolitan Museum in New York in 1999 and the V&A's 'Black British Style' in 2004. Casely-Hayford has also written a number of articles on fashion and associated social issues for i-D, True and Arena Homme Plus.

JAMES ANDERSON

"I am interested in the explosion caused when disparate cultural fragments collide"

PORTRAIT COURTESY OF JOE CASELY-HAYFORD

JOE CASELY-HAYFORD

PHOTOGRAPHY BY RUSSELL UNDERWOOD, STYLING BY DAVID LAMB. MAY 2002

Consuelo Castiglioni's Marni is a cult among modern-day bohemians. Her mis-matched prints, girlish silhouettes and gently faded fabrics that recall the patina of vintage cloth have made Marni one of fashion's most sought-after labels. And the Marni effect is felt far beyond her boutiques: Castiglioni's choice of, say, ponyskin clogs or a rosette corsage have provoked popular fashion trends that arrive with the force of a flash flood. At the age of 25, she married Gianni Castiglioni, president of CiwiFurs, a prestigious Italian furrier. After raising two children, she worked as a fashion consultant for her husband's company, launching her own collection in 1994, christened Marni. The Milan-based label was produced by CiwiFurs and initially specialised in fur and leather. However, Castiglioni broke from traditional techniques; in place of bulky, rich-bitch coats she offered unlined pelts that were shaved, tailored and dyed. In 1999 her line became completely independent and fur has given up centre stage to a colourful hotchpotch of luxurious fabrics and haberdashery: eclecticism is the allure of Marni, which is often viewed by the Italian fashion establishment as an eccentric label. Castiglioni will pass over flagged trends to steer her own course; she has eschewed money-spinning license deals and heavy marketing. Instead, she has favoured a stealthier route, captivating an ever-growing audience for her show of artful decoration and neat but naïve tailoring. In October 2001 Castiglioni introduced a menswear line and Marni now has five boutiques around the world. Yet even in the serious business of retail Castiglioni is playful, hiring maverick architects Future Systems to design startling curvilinear interiors for her stores.

"It's dressing with patchworks of fragments"

PORTRAIT BY SERGIO CALATRONI

CONSUELO CASTIGLIONI

PHOTOGRAPHY BY MATT JONES, STYLING BY JASON FARRER. SEPTEMBER 2001. MODEL: AALIYAH

Roberto Cavalli (born 1940, Florence) designs some of the most glamorous clothes in fashion: baroque combinations of exotic feathers, overblown florals, animal prints and incredibly lightweight leathers comprise the signature Cavalli look for day or night, which is always shown on his Milan runway atop the highest heels and with the biggest, blow-dried hair in the city. In winter collections, fur – the more extravagant the better – is dominant. And to think it all started on a ping-pong table. This is where, as a student at Florence's Academy of Art, Cavalli first began to experiment with printing on leather, later patenting a similar technique. The son of a tailor and the grandson of a revered painter (of the Macchiaioli movement), Cavalli is an expert embellisher and decorator of textiles. After founding his own fashion company in the early '60s, Cavalli was one of the first to put leather on a catwalk, patchworking it together for his debut show in 1972, which was staged at the Palazzo Pitti in Florence. Cavalli was an outsider to high fashion during the '80s, but staged a remarkable comeback in the '90s. In this renaissance period, Cavalli has become the label of choice among the R&B aristocracy, not to mention any starlet with both the bravado and the body to carry off one of his attention-seeking frocks. Assisted by his second wife Eva Düringer, a former Miss Universe, Cavalli brought his distinctive look – a unique combination of thrusting sex appeal, artisanal prints and frankly eccentric themes and catwalk shows – to the Milan collections, where press and clients alike received him with open arms. The collections bearing his name now include Just Cavalli, a menswear line, a childrenswear line and perfume licences, among others. In 2003 his company scored a turnover of E 289 million and its collections are distributed in over 30 countries. Cavalli also owns one of Italy's best racehorse stud farms.

SUSIE RUSHTON

"Nature is my main source of inspiration – I will never stop taking hints from what I call 'the greatest artist'"

PORTRAIT BY DERRICK NIMO

ROBERTO CAVALLI

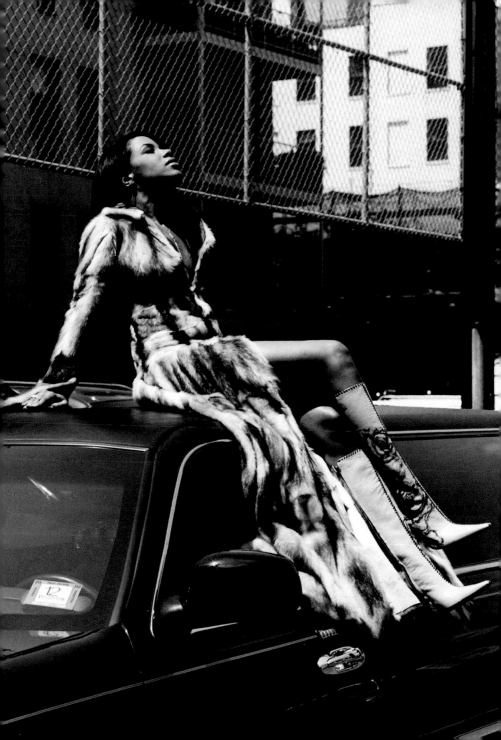

PHOTOGRAPHY BY HIROSHI KUTOMI, STYLING BY RACHAEL ZILLI. OCTOBER 2002

Like any major fashion name, deluxe LVMH brand Céline has kept its A-list status by marketing the kind of must-have products that spawn waiting lists from Manhattan to Milan. But, uncharacteristically enough, when the first Céline boutique opened in Paris in 1945, its focus was on hard-wearing children's shoes. It wasn't until 1959 that a womenswear initiative was launched and it was another three years later that the famous three horse-bit link started to adorn shoes, accessories and, of course, handbags. Céline finery has adorned the most chic ladies ever since. In 1998, the American Michael Kors was appointed chief designer of the ready-to-wear womenswear line — the first ever — and in 1999 he went onto become the company's creative director. Under his leadership, Céline became renowned for super-charged, ultra-luxurious womenswear. When the private-jet set needed something to go with their diamonds, their first stop was Céline. And it was a recipe for success: sales in the brand's 100 stores worldwide shot up to a record high. April 2004 saw Kors' contract come to an end and new designer Roberto Menichetti step into his shoes. Menichetti, who was first discovered by Claude Montana, has an impressive career history that includes both Jil Sander and an artistic director role at Burberry. His own label, Menichetti, launched in New York in February 2004, and his first collection for Céline hit the stores for spring/summer 2005; Menichetti has set tongues wagging with his experimental and streamlined vision of what the Céline customer should be wearing — a dramatic departure from Kors's glamour-puss aesthetic.

TERRY NEWMAN

"There's no point in design for design's sake. Everything I believe in is about getting women dressed"

MICHAEL KORS / PORTRAIT COURTESY OF MICHAEL KORS

CÉLINE

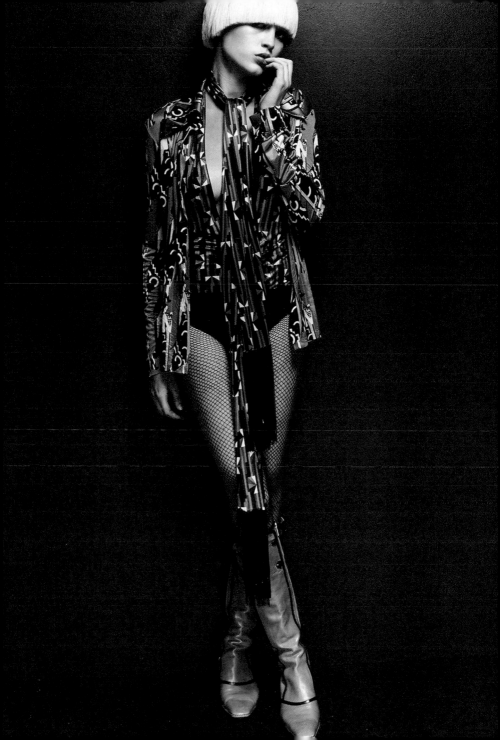

Hussein Chalayan (born 1970) takes a conceptual approach to fashion, pushing clothing across generic boundaries into sculpture, furniture, performance art and beyond. Since his graduate collection at Central Saint Martins in 1993 where clothes were buried in the ground for several weeks, he has confirmed his reputation as one of the most original designers working anywhere in the world today. Chalayan is famed for his spectacular shows in which anything could happen, from coffee tables turning into dresses to the use of confessional boxes and trampolines as catwalk props. At the same time, the designer's attention to technical detail, structure and stitching is exceptional. His collections have often focused on cultural displacement, something which Chalayan himself has experienced; his spring/summer 2003 collection 'Kinship Journey', for example, was inspired by Viking, Byzantine, Georgian and Armenian cultures. Born in Nicosia to Turkish-Cypriot parents, at the age of 12 Chalayan left Cyprus to attend school in England. Aside from his eponymous label, Chalayan has during his career worked for cashmere brand TSE and was appointed creative director of Asprey in 2001, departing the company in 2004. His creative touch-stones are science and new technology. He is a twice-crowned British Designer of the Year, having picked up the prize in 1999 and 2000. Chalayan now shows in Paris although his studio remains in London, and his work is as likely to be seen in international art spaces as on the catwalk. Recent awards include the Tribe Art Commission, from which he made the short film 'Place to Passage' (2003). 2004 saw Chalayan open his first store in Tokyo; to complement his existing womenswear and menswear collections, in 2005 he also launched a younger line, 'Chalayan'. In the same year, the Netherlands' Groningen Museum mounted a full-scale retrospective exhibition of the designer's work. SKYE SHERWIN

"My inspiration comes from anthropology, genetic anthro-pology, migration, history, social prejudice, politics, displacement, science fiction and, I guess, my own cultural background"

PORTRAIT BY SOLVE SUNDSBO

HUSSEIN CHALAYAN

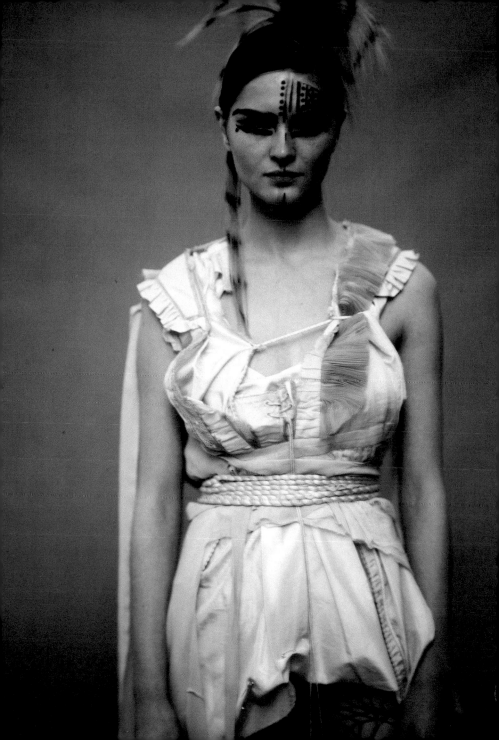

PHOTOGRAPHY BY MICHEL MOMY, STYLING BY YASMINE ESLAMI. AUGUST 2002

It's hard to believe that a world-renowned brand like Chloé – currently headed up by British designer Phoebe Philo – should have its origins in six cotton poplin dresses. But from humble cotton acorns, big fashion oaks grow. Egyptian-born Gaby Aghion first arrived in Paris in 1945 and created Chloé in 1952, producing a small collection of dresses; Maria Callas and Grace Kelly were early fans. A young Karl Lagerfeld (with only a year's design experience at Jean Patou under his belt) was appointed house designer in 1966. During the late '60s and '70s, the label blossomed. Legend has it that heiress Christina Onassis bought 36 blouses in one visit to the boutique. The '80s were a time of upheaval for Chloé, with Lagerfeld decamping to Chanel (1983) and the luxury goods company Richemont Group buying out Aghion (1985). Following Lagerfeld's departure, Martine Sitbon took over, bringing her trademark graphic sensibilities to Chloé. Although Lagerfeld returned once again to the house in 1992, it was Stella McCartney in 1997 who next transformed the brand's fortunes. McCartney's fusion of a London rock'n'roll vibe with Chloé's chic Parisian heritage revived the brand for a new generation. When McCartney's celebrity friends – Kate Moss, Madonna, Cameron Diaz – began to wear the clothes, the label's status was further established. McCartney's friend Phoebe Philo, who had worked closely with Stella throughout her four-year reign, has further improved on the brand's youthful and feminine reputation – delicate, vintage-style camisole tops and sexy trousers are signatures – since taking over in 2001. Philo, who was born in Paris in 1973 and graduated from Central Saint Martins, also initiated a diffusion line, See. She picked up a British Designer of the Year prize in 2004 and is now at the helm of a bona fide success story. LAUREN COCHRANE

"I'm inspired by sunsets, sunrises, being with horses and love"

PHOEBE PHILO / PORTRAIT COURTESY OF PHOEBE PHILO

CHLOÉ

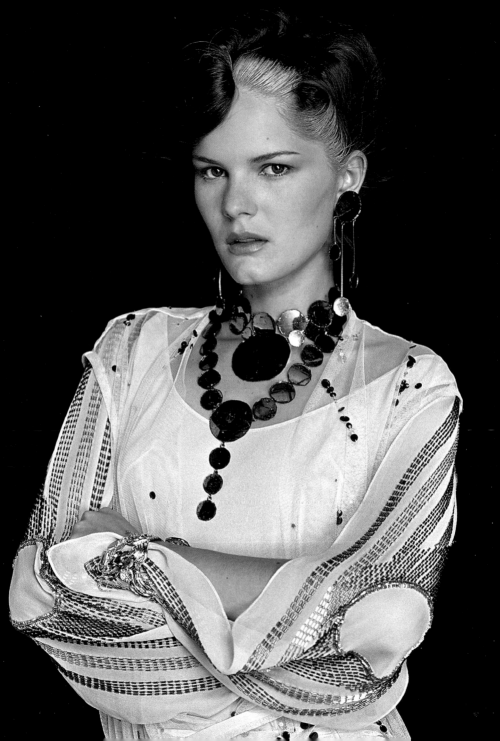

PHOTOGRAPHY BY NATHANIEL GOLDBERG, STYLING BY SORAYA DAYANI. JULY 2001

Jean Colonna brought the dark side of Paris's Pigalle nightclubs, left-bank sex clubs and S&M shops onto the catwalk. He championed deconstruction in the early '90s, making clothes in deliberately cheap fabrics and shoddy finishes. Yet Colonna wanted to make his clothing accessible for all, not just fashion victims who thought his 'pauvre chic' was an amusing joke. Truly an 'enfant terrible', Colonna had a surprisingly conventional training. Born in Algeria in 1955, Colonna was raised in Aix-en-Provence and moved to Paris in 1975, where he studied at the Ecole de la Chambre Syndicale de la Couture Parisienne. After graduating, Colonna assisted couturier Pierre Balmain. In 1985 he presented his first collection, eschewing the catwalk in favour of catalogues shot by friends Bettina Rheims and Stéphane Sednaoui. He also designed jewellery and accessories for contemporaries Claude Montana, Thierry Mugler and Jean Paul Gaultier. 1990 saw Colonna take his collections to the runway and pioneer the use of monolithic warehouse spaces and gawky androgynous models. Colonna was at the vanguard of deconstruction, and his all-black collections were reminiscent of '70s 'slash and burn' punk. His use of cheap sex-shop cloths such as lamé, leatherette and PVC, and hems unceremoniously over-locked or left raw were a deliberate slap in the face for bourgeois Parisian fashion. During this period, Colonna collaborated with photographer David Sims on a 1993 window for French department store Le Printemps. Deconstruction soon lost its charm and between 1993 and 1994 Colonna was designing capsule collections for French mail-order company La Redoute. Overlooked by those who don't support Colonna's message (real clothes for real people), the designer remains a maverick talent in French fashion with a cult following in Japan. JAMES SHERWOOD

"Fashion, which is drowned in rules, couldn't have a revolutionary ambition"

PORTRAIT COURTESY OF JEAN COLONNA

JEAN COLONNA

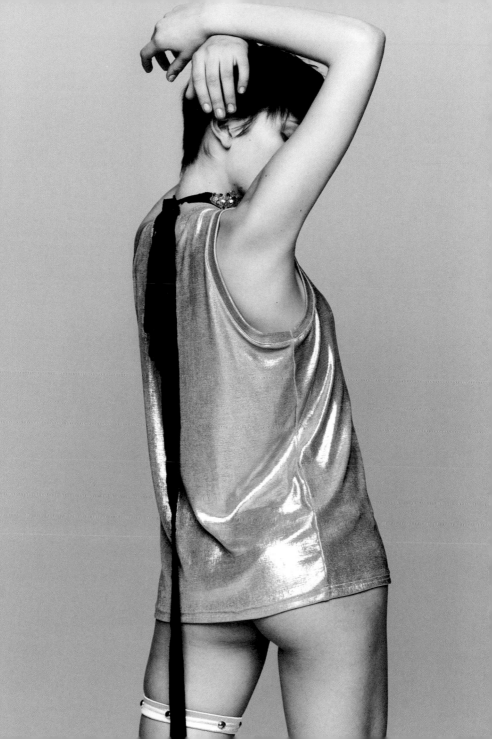

PHOTOGRAPHY BY RICHARD BUSH, STYLING BY JANE HOW. OCTOBER 2002

Rei Kawakubo may be better known to many under the name of the label she established in Tokyo in 1973, and for which she showed her first collection two years later: Comme des Garçons, a moniker chosen, the designer has said, simply because she liked the sound of it. Certainly it is a name readily on the lips of the many other designers who invariably cite Kawakubo as an inspiration. A designer who has dispensed with the rule book, who cuts and constructs in such a way that her clothes have skirted art, Kawakubo's readiness to challenge conventions – to produce uniform-like clothes that are neither obviously for men nor women, that distort rather than enhance the female form, that use atypical fabrics and deconstruct them sometimes to the point of destruction – has nevertheless created a global concern. She launched Comme to the West in 1981, when she showed her first collection in Paris and was among the avant-garde Japanese to introduce black as an everyday fashion staple – unthinkingly dubbed 'Hiroshima Chic' by some critics. Then as now, it bewildered as much as it excited. The self-taught, multiple award-winning Kawakubo (born in Tokyo in 1942) did not, however, follow the standard route into the fashion industry. She began her career by reading literature at Tokyo's Keio University and, on graduation in 1964, joined the Ashai Kasei chemical and textiles company, working in its advertising department. Unable to find the garments she wanted for herself, she started to design them. She launched menswear in 1978, and a furniture line in 1982. Comme remains progressive: the label's fragrances, for instance, have played with tar, rubber and nail polish odours. Recent retail projects have included short-term 'guerrilla' stores in the backwater areas of, for the fashion world, unexpected cities, through to London's monolithic Dover Street Market, in which the company, which she co-runs with British husband Adrian Joffe, also rents space to other like-minded designers. JOSH SIMS

"The same spirit runs through everything I do"

REI KAWAKUBO / PORTRAIT BY TIMOTHY GREENFIELD

COMME DES GARÇONS

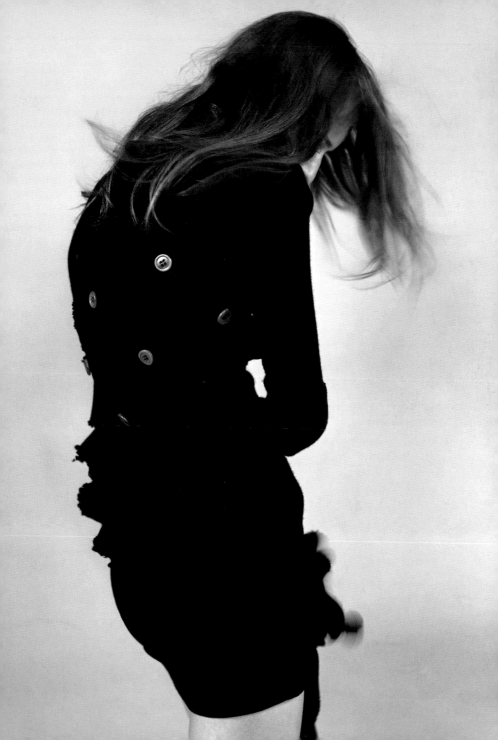

PHOTOGRAPHY COURTESY OF COSTUME NATIONAL. AUTUMN/WINTER 2002

Born in Puglia, Lecce in 1960, Ennio Capasa was influenced by oriental culture from an early age, and travelled around Japan when he was 18 before being accepted into the sculpture course at Milan's Academia di Belle Arti di Brera. On graduation, Capasa was invited to return to Japan to train under Yohji Yamamoto, who had been sent some of Capasa's illustrations by a friend. He stayed for three years (1982–1985), before setting up the label Costume National in Milan in 1986 with his brother Carlo (who had himself worked with Romeo Gigli and as consultant to Dawn Mello at Gucci). Combining Japanese purism with a more streetwear-influenced silhouette, the first Costume National women's ready-to-wear collection appeared in 1987, along with a shoe collection. However, reaction to Capasa's sensual, minimalist vision was muted in Milan (where the fashion federation had refused requests by Japanese designers to show in the early '80s), so in 1991 they decided to follow Yamamoto and Rei Kawakubo to Paris. It was in France that they found the respect of critics and peers alike and in 1993 they added a men's footwear range and a ready-to-wear menswear collection (partly because Ennio, a self-confessed "vintage addict", was unable to find pieces to wear himself). In 2000, bags, lingerie and leather accessories were added, together with Costume National Luxe, featuring a limited series of garments made from particularly precious and unusual materials. Footwear now comprises around a third of the business, and the company owns its own shoe factory in Padua, an apparel plant near Vicenza and a leather treatment company near Lecce – not to mention flagship stores in Milan, Rome, Paris, New York, Los Angeles, Tokyo, Osaka and Hong Kong. In 2002, a fragrance line (the typically minimalist 'Scent') was launched, followed by eyewear a year later. MARK HOOPER

"There is no distinction between who I am and what I do"

ENNIO CAPASA / PORTRAIT COURTESY OF ENNIO CAPASA

COSTUME NATIONAL

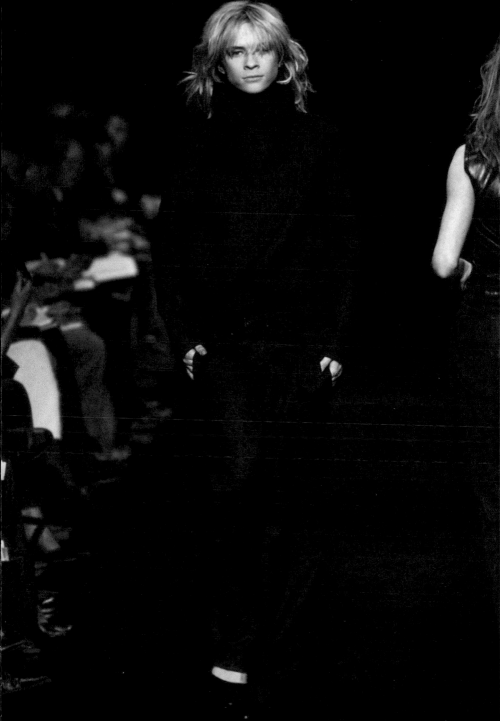

PHOTOGRAPHY BY TESH, STYLING BY EDWARD ENNINFUL. NOVEMBER 2001

Ann Demeulemeester once told an interviewer that women are not like Barbie dolls, and that she finds a subtle femininity in men most pleasing. Inevitably, then, her own designs for both sexes are far removed from the types of clothing in which bimbos and himbos might typically attire themselves. Hers is a far more personal, subtle and emotional aesthetic, one frequently, and lazily, labelled as androgynous, but which could more accurately be termed as romantically modernist. Born in Belgium, in 1959, Demeulemeester went on to study at Antwerp's Royal Academy, from which she graduated in 1981, as part of the now-legendary Antwerp Six group of designers. In 1985 she launched her own label, along with her husband Patrick Robyn – a man she has cited as her biggest influence – and made her womenswear debut in Paris in 1992. By 1996 she would also be designing menswear collections. Given her long-entrenched fondness for the colour black (she has mainly clad herself in black, since her Patti Smith-loving teens) along with the severity of her earlier work, with its wilfully unfinished look, she became known as a key figure of the deconstruction era of fashion during the late '80s and early '90s. Avoiding the fickle whims and fads of the fashion industry, Demeulemeester has subsequently carved out her own unique niche, not to mention a loyal fan-base which continues to grow. Not surprisingly, the designer now also creates extremely successful shoe and accessory lines, and her collections are sold in over 30 countries around the world. She continues to champion clothing that favours high quality, natural materials – leather, wool and flannels – over less covetable synthetic fabrics, and her poetic mix of edgy rebellion with sensuality, plus slick tailoring with softer layers, creates an ever-intriguing design proposition.

JAMES ANDERSON

"Fashion has a reason 'to be' because in fashion you can find new kinds of expressions about human beings"

PORTRAIT BY KEVIN DAVIES

ANN DEMEULEMEESTER

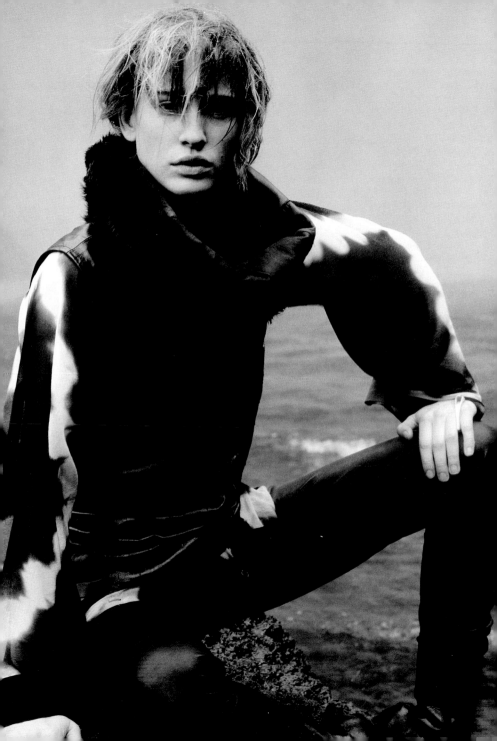

PHOTOGRAPHY BY JUERGEN TELLER. JULY 2001. MODEL: TRICKY

Renzo Rosso (born 1955) is the force behind iconic Italian company Diesel. Renowned for its jeans, the brand is as equally acclaimed for its advertising campaigns. The brand's multi-award-winning catch line – 'Diesel: For Successful Living' – parodies advertising's dictum that products will make you happy, and encapsulates Rosso's confrontational, ironic fashion ethos. The son of a peasant farmer, Rosso studied industrial textile manufacturing in his native Padua, followed by economics at university in Venice. Something of a master entrepreneur, in 1978, before his degree was completed, he co-founded the influential Genius Group to develop new fashion brands, among them Replay and Diesel. In 1985 Rosso acquired Diesel and by 1991 had unified its first global marketing strategy. In 2000 the company acquired Staff International, holding agent for Dsquared, Martin Margiela and Vivienne Westwood Red Label. New brands have also been launched, among them Diesel Kids, 55 DSL and the experimental Diesel Style Lab. Diesel has an annual turnover in excess of ¤ 750 m and even has its own hotel, the Art Déco Pelican on South Beach, Miami, and a farm in the Maristoca hills that produces wine and olive oil. Still true to its core product, Diesel recently launched the Diesel Denim Gallery, offering specially-treated jeans billed as one-of-a-kind denim art pieces. While the brand is sold in over 80 countries, Diesel denim jeans remains 100 per cent made in Italy.

SKYE SHERWIN

"I think that Diesel is special because we have always had our own views on styles and trends"

RENZO ROSSO / PORTRAIT COURTESY OF RENZO ROSSO

DIESEL

PHOTOGRAPHY BY STEVEN KLEIN, STYLING BY PATTI WILSON. APRIL 2000. MODEL: L'IL KIM

Dolce & Gabbana are fashion's answer to Viagra: the full throbbing force of Italian style. The winning combination of Dolce's tailoring perfectionism and Gabbana's stylistic theatrics has made the label a powerhouse in today's celebrity-obsessed age and just as influential as the ambassadors of sport, music and film that they dress. Domenico Dolce was born in 1958 to a Sicilian family, his father a tailor from Palermo who taught him to make a jacket by the age of seven. Stefano Gabbana was born in 1962, the son of a Milanese print worker. But it was Sicily, Dolce's birthplace and Gabbana's favourite childhood holiday destination, that sealed a bond between them when they first met, and which has provided a reference for their aesthetic signatures ever since: the traditional Sicilian girl (opaque black stockings, black lace, peasant skirts, shawl fringing), the Latin sex temptress (corsetry, high heels, underwear as outerwear), and the Sicilian gangster (pinstripe suits, slick tailoring, fedoras). And it is the friction between these polar opposites – masculine/feminine, soft/hard and innocence/corruption – that makes Dolce & Gabbana so exciting. Established in 1985, the label continues to pay homage to such Italian film legends as Fellini, Visconti, Rossellini, Anna Magnani and Sophia Loren; in glossy art books, Dolce & Gabbana documents its own contribution to today's legends of film ('Hollywood'), music ('Music') and football ('Calcio'). With an empire that includes the younger D&G line, childrenswear, swimwear, underwear, eyewear, fragrance (eight in total), watches, accessories and a global distribution through their own boutiques, Dolce & Gabbana are, quite simply, fashion's Italian stallions. JAMIE HUCKBODY

"We are both creative, both in a different way. We complete each other"

DOMENICO DOLCE AND STEFANO GABBANA
PORTRAIT BY FABRIZIO FERRI

DOLCE & GABBANA

PHOTOGRAPHY BY JEREMY MURCH, STYLING BY LYNETTE GARLAND. OCTOBER 2002

Eley Kishimoto are British fashion's favourite double act. Best known for their boldly innovative prints, husband-and-wife design team Mark Eley and Wakako Kishimoto are recognised foremost as womenswear designers, but also work their magic on furniture, wallpaper, ceramics and glass, plus a tidy range of see-them-want-them accessories that includes sunglasses, hats, bags, shoes and hosiery. Eley was born in Wales and graduated from Brighton Polytechnic in 1990 with a degree in fashion and weave. Kishimoto (born in Sapporo, Japan, in 1965) finished her fashion and print degree at Central Saint Martins in 1992 at which time the pair founded their own label, designing prints for the likes of Joe Casely-Hayford, Hussein Chalayan and Alexander McQueen. In 1995 their debut fashion collection, 'Rainwear', hit town – cheerfully prim printed fabric umbrellas, coats and gloves. Since then, wave after wave of imaginative and stylish products has kept coming from the Eley Kishimoto studio and from 2001 they have shown at London Fashion Week. EK have gained a reputation for their own designs as well as securing print commissions from international labels such as Marc Jacobs, Jil Sander and Yves Saint Laurent. They also work as consultants for textile producers in Italy and Japan, and in 2002 the V&A Museum presented a retrospective exhibition of the duo's work. In 2003 they opened a shop in Bermondsey, south London, and signed a manufacturing deal with CIT Spa in Milan, enabling further expansion. Spring 2005 heralded the first Eley Kishimoto-Ellesse collection – part of a three-season deal – and also a new collaboration with luggage brand Globetrotter who utilised the classic EK print 'flash' on their classic cases. Here's to the queen and king of prints charming!

TERRY NEWMAN

"Our work is our life, so our daily activities, whether work or play, are intrinsically involved with our creative output"

MARK ELEY AND WAKAKO KISHIMOTO
PORTRAIT BY FLO KOLMER

ELEY KISHIMOTO

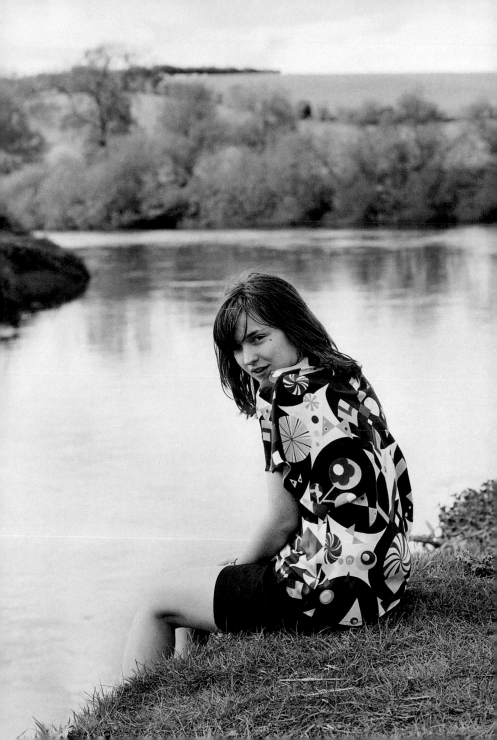

PHOTOGRAPHY BY THOMAS SCHENK, STYLING BY JOANNA BLADES. MARCH 2000

Fendi is a house of extremes: big furs and little handbags, a family business with a worldwide reputation, a chic past and a street-cool future. Established in 1925, the Fendi empire was founded by Adele Fendi from a small leather-goods shop and workroom in Rome, where she and her husband Eduardo worked with private clients. The family business expanded with the opening of a larger shop in 1946, but it wasn't until the death of Eduardo, eight years later, that the modern Fendi image emerged, when the family's five daughters injected the little company with some youthful glamour. After the death of Adele in 1978, each sister adopted a corner of the empire to look after. Paola (born 1931) worked with the furs, Anna (born 1933) the leather goods, Franca (born 1935) the customer relations, Carla (born 1937) the business co-ordination, and Alda (born 1940) the sales. By the end of the '80s, the name of Fendi had become shorthand for jet-set elitist luxury, thanks to its signature furs and instantly recognisable double F logo (designed by Karl Lagerfeld). The politically correct '90s saw the company re-focus on Adele Fendi's traditional leather goods, and so the Baguette bag was re-born and Fendi's star was in the ascendant yet again. Amid the late-'90s' appetite for baroque excess, LVMH and Prada bought a 51 per cent stake in the label, with LVMH eventually becoming the sole partner in 2001. But Fendi is still very much a family business. The future lies with Maria Silvia Venturini Fendi (born 1960, the daughter of Anna Fendi), who created the Fendissime line in 1987 and is now designer of accessories and menswear. Karl Lagerfeld, as chief designer, continues to work with the sisters – as he has done since 1965 – and Maria Silvia. JAMIE HUCKBODY

"When I design, sometimes I have sensations which I could call 'visionary'"

MARIA SILVIA VENTURINI FENDI / PORTRAIT BY KARL LAGERFELD

FENDI

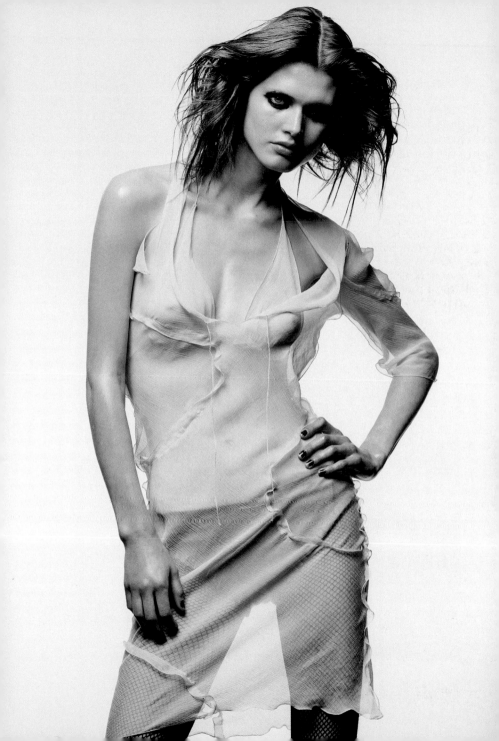

PHOTOGRAPHY BY KAYT JONES, STYLING BY BELLAN CASADEVALL. APRIL 2001. MODEL: LIBERTY ROSS

As a woman famed for her fragile little dresses blown together from raw-edged chiffon, appliquéd ribbon and intricate rivulets of beading, Alberta Ferretti is an unlikely player in the boardroom wars of the world's luxury goods groups. Yet Aeffe SpA, the company she founded in 1980 with her brother Massimo as chairman, now owns the controlling stake in Moschino and brokered production and distribution deals with Jean Paul Gaultier (1994) and Narciso Rodriguez (1997). As well as Alberta Ferretti and her successful diffusion line, Philosophy di Alberta Ferretti, Aeffe owns swimwear/lingerie label Velmar and shoemaker Pollini. Born in 1950 in Cattolica, Italy, Ferretti is the daughter of a dressmaker and was raised assisting in her mother's atelier. Not for her the sharp, tight and angular silhouettes of the male Parisian couturiers. Ferretti was inspired instead by a lyrical femininity and fluidity as celebrated in the Fellini movies being made around Cattolica in the 1950s. At the age of 18, Ferretti opened a boutique in her hometown and in 1974 unveiled her own label. 1980 saw Alberta and Massimo go into business together. Alberta Ferretti's debut on the catwalk in Milan came in 1981 with sheer, ethereal chiffons and pin-tucked satin dresses. In 1994 Aeffe annexed the medieval village of Montegridolfo as its Italian headquarters and more than a decade later her collections look as relevant today as they did when Ferretti first proposed delicate, romantic but modern fashion for the new bohemian woman. JAMES SHERWOOD

"I try to transform a dream's magic into reality"

PORTRAIT COURTESY OF ALBERTA FERRETTI

ALBERTA FERRETTI

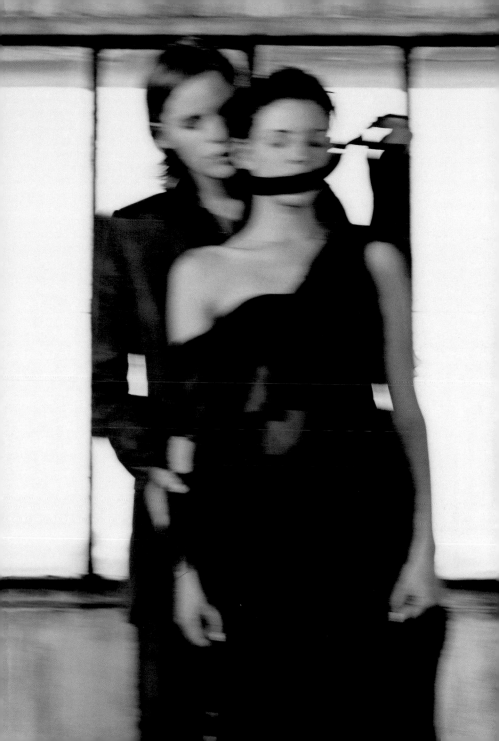

PHOTOGRAPHY BY STEVEN KLEIN, STYLING BY EDWARD ENNINFUL. MAY 2002. MODEL: NATALIA V

John Galliano is one of Britain's fashion heroes. Born in 1960 to a working class Gibraltan family, Galliano lived on the island until leaving at the age of six for south London. But it was the young Juan Carlos Antonio's early life, with its religious ceremonies and sun-drenched culture, which has proved a constant inspiration for Galliano; stylistic eclecticism wedded to the Latin tradition of 'dressing-up' has become his signature. Having attended Wilson's Grammar School for boys, Galliano won a place at Saint Martins College, graduating in 1984. And it was that graduation collection – inspired by the French Revolution and titled 'Les Incroyables' – that was bought by Joan Burstein of Browns, catapulting the young designer into the spotlight. In 1990 – after suffering a period notorious for problems with backers and collections deemed uncommercial because they dared to dream beyond the conventional – Galliano started to show in Paris, moving to the city in 1992. A champion of the romantic bias-cut dress and the dramatic tailoring of '50s couture at a time when minimalism and grunge dominated fashion, it was announced in 1995 that Galliano would succeed Hubert de Givenchy at the dusty maison de couture. Two seasons later, and with an unprecedented four British Designer of the Year awards under his belt, Galliano became creative director at Christian Dior, presenting his first collection for the spring/summer 1997 haute couture show. Since then, Galliano has financially and creatively revitalised the house, while continuing to design his own collections for men and women in Paris, a city where he is accorded the status of fashion royalty.

JAMIE HUCKBODY

"I am here to make people dream, to seduce them into buying beautiful clothes and to strive to make amazing clothing to the best of my ability. That is my duty"

PORTRAIT BY SEAN ELLIS

JOHN GALLIANO

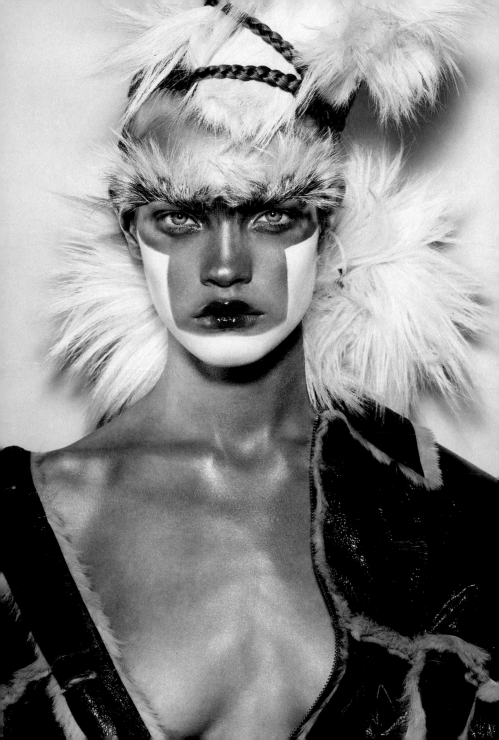

PHOTOGRAPHY BY KAYT JONES, STYLING BY GERIADA KEFFORD. JUNE 2001. MODEL: LAETITIA CASTA

The former 'enfant terrible' of French fashion is one of the most significant designers working today, his appeal bridging the elite and mass markets. On one hand, Jean Paul Gaultier is hailed as the saviour of haute couture (Gaultier Paris was launched 1997) and since 2004 has designed refined womenswear for Hermès, alongside his own well-established ready-to-wear label. On the other, he is one of the world's most famous living Frenchmen, partly due to a presenting job on the TV show Eurotrash in the early '90s (not to mention his personal fondness for striped Breton shirts and other Gallic clichés). Born in 1952, he was beguiled by fashion from a young age and would sketch showgirls from the Folies Bergère to impress his classmates. In the early '70s he trained under Pierre Cardin and Jean Patou, eventually launching his own ready-to-wear collection in 1976. He soon became known for iconoclastic designs such as the male skirt, corsetry worn as outerwear, and tattoo-printed body stockings. The classics of Parisian fashion are also central to his repertoire, particularly the trench coat and le smoking. In 1998 he launched a diffusion line, Junior Gaultier (since replaced by JPG), followed by excursions into perfumes (1993), and film costume (notably for Luc Besson's 'The Fifth Element' and Peter Greenaway's 'The Cook, The Thief, His Wife and Her Lover'). But it was his wardrobe for Madonna's Blonde Ambition tour of 1990 that made him world-famous, in particular for a certain salmon-pink corset with conical bra cups. A celebrity and a genius possessed of both a piquant sense of humour and a deadly serious talent, in 2004 Gaultier staged an unique exhibition at the Fondation Cartier in Paris, entitled 'Pain Couture', that showcased clothing constructed entirely from bread.

SUSIE RUSHTON

"I didn't want to be famous"

PORTRAIT BY CHRISTIAN BADGER

JEAN PAUL GAULTIER

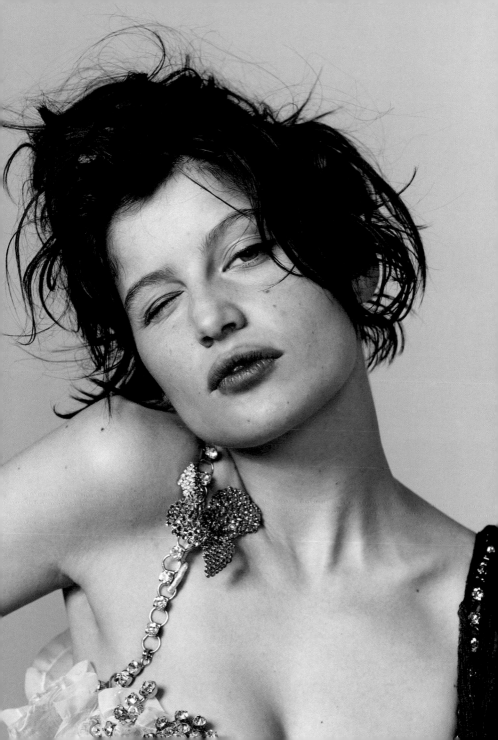

PHOTOGRAPHY BY MATT JONES, STYLING BY WILLIAM BAKER AND SIMONEZ. JANUARY/FEBRUARY 1998

Inspired by the America of the European imagination, the Girbaud brand brings the work garment of the cowboy, blue jeans, to those raised on a diet of American music and cinema. Steering their work away from the edicts of fashion, Marithé and François Girbaud strive to create garments that complement the realities of life and style. Laser-cut, Lycra-fused, distressed and ripped denims are used to create clothing that is both striking and wearable. Comfort and functionality are placed on an equal footing. Despite their innovative approach to design, the couple stress that their work is governed more by attitude than by trend. Both born during the '40s, Marithé and François met in 1960 and by 1964 had begun to import cowboy clothing for Western House, the first Parisian boutique of its kind. Over the next few years they began to tamper with the classic blue jeans template, employing harsh cleaning and abrasive techniques to soften and fade denim, creating the stonewashed look that now dominates the marketplace. In 1969 they signed their first licensing agreement for the brand CA, and in 1972 they opened their first shop, Boutique, in Les Halles, Paris. The Girbauds continued to experiment, and in 1986 they made their first appearance at Paris Fashion Week, finally designing under their own name. Since then the brand has grown exponentially, and now claims stores and franchises in several countries throughout the world. Building on the foundations laid by jeans design, the Girbaud brand has expanded into other areas, including footwear and accessories, sportswear and glasses. Although jeans and denim detail remain a recurring theme throughout their work, the Girbauds' collections now include a variety of fabrics and print designs that range from leather and tartan to pinstripe and floral cotton. DAVID VASCOTT

"We have always favoured the collaboration between a man and a woman who are very different"

PORTRAIT COURTESY OF MARITHÉ & FRANÇOIS GIRBAUD

MARITHÉ & FRANÇOIS GIRBAUD

PHOTOGRAPHY BY STEVE SMITH, STYLING BY MARK ANTHONY. MODEL: MATT G.

In March 2005 Frida Giannini was charged with pushing Gucci, one of the most recognisable status labels of the late 20th century, into a new era. She is responsible for its high-profile accessories and womenswear collections, which has become synonymous with figure-hugging pencil skirts, glamorous sportswear and vixen-ish evening-wear, a look established by Gucci's former designer, Tom Ford, during the '90s. Established in 1921 by Guccio Gucci as a saddlery shop in Florence, the company had been a traditional family-run Italian business until Guccio's grand-son Maurizio sold his final share of the brand in 1993. It was Guccio who first intertwined his initials to create the iconic logo. Yet until Tom Ford came along in the mid-'90s, the brand's image was lacklustre; from autumn/winter 1995, Ford designed full womenswear collections for Gucci, supported by slick advertising campaigns often shot by Mario Testino and a die-hard following among celebrities. In 2004, Ford exited Gucci and its parent company, the Gucci Group (which also controls brands such as Stella McCartney, Yves Saint Laurent Rive Gauche, Balenciaga and Alexander McQueen), and new management filled Ford's position not with a single designer but with a team of three, all of whom were promoted internally: John Ray, for menswear, Alessandra Facchinetti for womenswear and Frida Giannini for accessories. In March 2005 Facchinetti also departed Gucci, and Giannini, who lives in a 15th century apartment in Florence and owns 7000 vinyl records, is now also responsible for women's clothing collections. Born in Rome in 1972, Giannini studied at the city's Fashion Academy; in 1997 she landed a job as ready-to-wear designer at Fendi, before first joining Gucci in 2002. Her 'Flora' collection of flowery-printed acces-sories was the commercial hit of 2004, and, at the time of writing, her first ready-to-wear collection was sched-uled for autumn/ winter 2005. SUSIE RUSHTON

"I think of a mood, a way of living, of certain needs"

FRIDA GIANNINI / PORTRAIT COURTESY OF GUCCI

GUCCI (WOMENSWEAR)

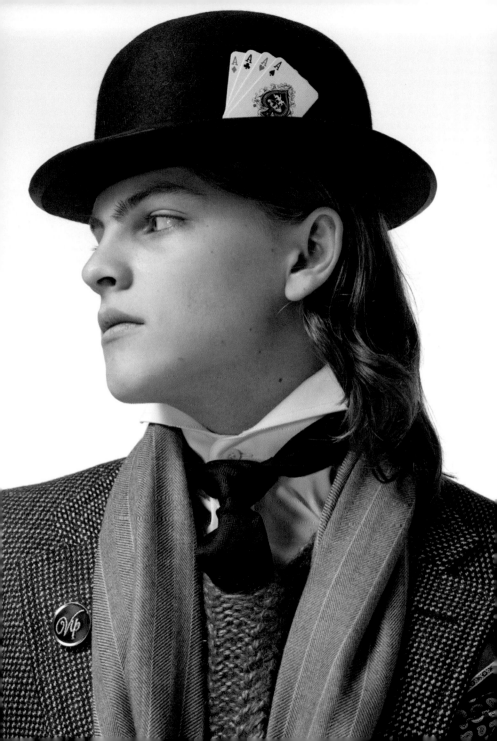

PHOTOGRAPHY BY DONALD CHRISTIE, STYLING BY MARK MORRISON. JULY 2005. MODEL: PADDY

In March 2004, John Ray, then aged 42, was named as successor to Tom Ford as Gucci's creative director of menswear. Ray, who was born in Scotland, had already worked under Ford in the Gucci menswear studio for eight years. Gucci menswear had become known for its blatantly sexual and flamboyant style: figure-hugging trousers, flashy double-G logo belt buckles, velvet smoking jackets with wide '70s-style lapels and shiny satin shirts, worn unbuttoned to the (perfectly tanned) navel. Under Ray's direction – spring/summer 2005 was his first solo collection – Gucci menswear acknowledges that opulent template, with a softer and subtler edge. Ray also places a special emphasis on tailoring. His debut was based on an idea of exotic travel, and featured Moroccan-style kurtas embellished with coins, beads and embroidery; long caftans; paisley smoking suits; tiny swimming trunks. Ray, who describes himself as an extremely private person, grew up in Scotland and first worked as a graphic designer. At the age of 23 he realised fashion was his true calling, and enrolled on the menswear course at Central Saint Martins (1986), followed by an MA at the Royal College of Art (1989); while at fashion college, Ray used a Savile Row tailor to execute his student designs. In 1992 Ray joined Katharine Hamnett, where he eventually became head of menswear. In 1996 his career at Gucci began when Tom Ford hired him as a menswear consultant. By 1998 Ray was appointed senior menswear designer and in 2001 named vice president of menswear, overseeing all product categories. Ray, then, is as familiar with the evolution of the Gucci man as any designer could be. Like his counterpart in womenswear, Frida Giannini, Ray shows his collections in Milan. He lives and works in London.

SUSIE RUSHTON

"I am always attracted by the unknown and inspired by the undiscovered"

JOHN RAY / PORTRAIT COURTESY OF JOHN RAY

GUCCI (MENSWEAR)

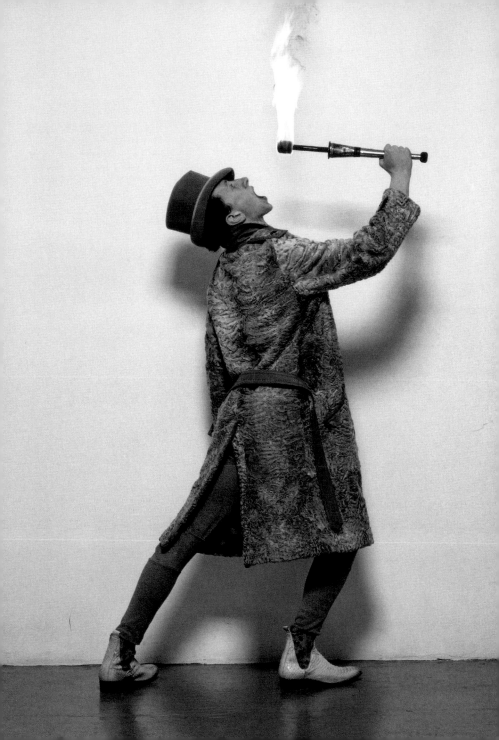

PHOTOGRAPHY BY ORION BEST, STYLING BY CLAIRE DURBRIDGE. MARCH 2000

For many fans, Katharine Hamnett defines '80s style. Her trademark use of functional fabrics such as parachute silk and cotton jersey has continued to inspire many in the industry since. She spearheaded a number of style directions including the military look, utility fashion, and casual day-to-evening sportswear, all of which still resonate today. And 21 years after her logo T-shirts first became front-page news (in 1984 she famously met Mrs Thatcher and wore one that read: '58% Don't Want Pershing') Hamnett can still make the fashion world sit up and pay attention to her ideas. Born in 1948, she graduated from Saint Martins College in 1969 and freelanced for 10 years before setting up her own label, Katharine Hamnett London. This was followed in 1981 by menswear and a denim diffusion range in 1982. She became the BFC's Designer of The Year in 1984 and her ad campaigns helped to launch the careers of photographers including Juergen Teller, Terry Richardson and Ellen Von Unwerth. Projects such as her flagship stores in London's Brompton Cross and Sloane Street, designed by Norman Foster, Nigel Coates and David Chipperfield, were famous for their forward-thinking retail design. A political conscience has always been key to the Katharine Hamnett ethos. She created anti-war T-shirts ('Life is Sacred') in 2003 that were widely worn by peace protesters marching in London; Naomi Campbell modelled a 'Use a Condom' design for Hamnett's spring/summer 2004 catwalk show in order to highlight the designer's concern over the Aids epidemic in Africa. She decided to relaunch as Katharine E Hamnett for autumn/winter 2005 and often voices her concerns about unethical and non-environmental manufacturing processes. TERRY NEWMAN

"Thank God I always wore dark glasses in the '80s. Nobody recognises me now"

PORTRAIT BY HAMISH BROWN

KATHARINE HAMNETT

PHOTOGRAPHY BY MICHEL MOMY, STYLING BY KANAKO B KOGA. MAY 2000

Latex from the Amazon jungle, bold splashes of colour, hectic prints allied to an often austere silhouette: all of these are signatures for Brazil's most prolific designer, Alexandre Herchcovitch. Of Romanian and Polish extraction but born in São Paulo, the designer knew at the age of ten what he wanted to do with his life. While attending a local Jewish orthodox school he made clothes and often dressed his mother, who ran a lingerie factory. The fashion training that followed was completed at the Catholic institution Santa Marcelina College of Arts, also in his home city. Herchcovitch wasted no time launching an eponymous line, which was first conceived and shown in Brazil in 1993. More recently his designs have been seen on the runways of London, Paris and New York. His spring/summer 2005 collection marked his debut in Manhattan where he transformed the catwalk into a bright, floral maze that clashed appropriately with his eclectic prints and colourful designs. Inspired by politics and art, Herchcovitch's unique Brazilian flavour is mixed with myriad influences which result in complex clothes for people who are not shy of making a statement. For example: a tailored jacket may look straightforward when viewed from the front, but a cascade of colourful fabric ruffles dance down its back, finishing in a floor-sweeping train. This kind of outfit illustrates his philosophy of producing wearable art for both men and women. However, Herchcovitch is savvy enough to know that flamboyance isn't for everyone, so simpler separates also feature in his collections. In addition to his menswear and womenswear lines, he also produces four denim collections a year, has two stores in São Paulo and boasts a handful of partnerships with major companies, including Converse. SIMON CHILVERS

"I am too emotional sometimes, but I rationally think about shape"

PORTRAIT BY LUKE THOMAS

ALEXANDRE HERCHCOVITCH

PHOTOGRAPHY BY MATT JONES, STYLING BY CATHY DIXON. JANUARY/FEBRUARY 2000

Born one of nine children in 1951 in Elmira, New York, Tommy Hilfiger's eponymous brand is often viewed as epitomising the American Dream. His career famously began in 1969 with $150 and 20 pairs of jeans. When customers to his People's Palace store in upstate New York failed to find what they were after, he took to designing clothes himself, with no previous training. In 1984, having moved to New York City, Hilfiger launched his first collection under his own name. With his distinctive red, white and blue logo and collegiate/Ivy League influences, Hilfiger presented a preppy vision of Americana which, coupled with his looser sportswear aesthetic, found a surprising new audience in the burgeoning hip-hop scene of the early '90s. Hilfiger, a dedicated music fan himself, welcomed this re-interpretation of his work, but rumours that he was less than enamoured by his new audience led him to make an admirable response, lending his support to the Anti-Defamation League and the Washington DC Martin Luther King Jr National Memorial Project Foundation. By 1992 his company had gone public and Hilfiger was named the CFDA's Menswear Designer of the Year in 1995. A new 'semi-luxe' line of tailored separates, entitled simply 'H', was launched in 2004 as a higher-priced, more upmarket addition to the global brand, which now incorporates everything from denim and eyewear to fragrances, homeware, sporting apparel and children's lines. In keeping with his music and fashion influences, Hilfiger chose to market his new 'grown-up' range by asking David Bowie and Iman to appear in ad campaigns for H. In December 2004 Hilfiger looked set on further expansion when he announced an agreement made with Karl Lagerfeld to globally distribute the latter's own-label collections. MARK HOOPER

"People always want something unexpected and exciting. That's what drives me"

PORTRAIT COURTESY OF TOMMY HILFIGER

TOMMY HILFIGER

Season after season, Marc Jacobs (born New York, 1963), manages to predict exactly what women all over the world want to wear, whether that be his super-flat 'mouse' pumps, Sergeant Pepper-style denim jackets or 'Venetia' handbags fitted with outsized silver buckles. Born in New York's Upper West Side to parents who both worked for the William Morris Agency, Jacobs was raised by his fashion-conscious grandmother. As a teenager, Jacobs immersed himself in club culture, observing the beautiful people at the Mudd Club, Studio 54 and Hurrah. Today, Jacobs' most fruitful source of inspiration is still the crowd of cool girls that surround him (including the stylist Venetia Scott, director Sofia Coppola and numerous art-house actresses). After high school, Jacobs completed a fashion degree at Parsons School of Design; his graduation collection (1984), which featured brightly-coloured knits, caught the eye of Robert Duffy, an executive who remains Jacobs' business partner to this day. Together they launched the first Marc Jacobs collection (1986), winning a CFDA award (the first of six, to date) the following year. In 1989 Jacobs was named head designer at Perry Ellis. His experience there was tempestuous and his infamous 'grunge' collection of 1992 – featuring satin Birkenstocks and silk plaid shirts – marked his exit from the company. By 1997 Jacobs' star was in the ascendant once again, when LVMH appointed him artistic director at Louis Vuitton. Jacobs has enhanced the luggage company's image – not least through his collaborations with artists Takashi Murakami and Stephen Sprouse on seasonal handbag designs – and re-positioned it as a ready-to-wear fashion brand. Meanwhile LVMH have supported Jacobs' own company, which has since launched Marc by Marc Jacobs (2001), his first perfume (2001) and a homeware collection (2003). SUSIE RUSHTON

"It's important for me that my clothes are not just an exercise in runway high jinks"

PORTRAIT BY DUC LIAO

MARC JACOBS

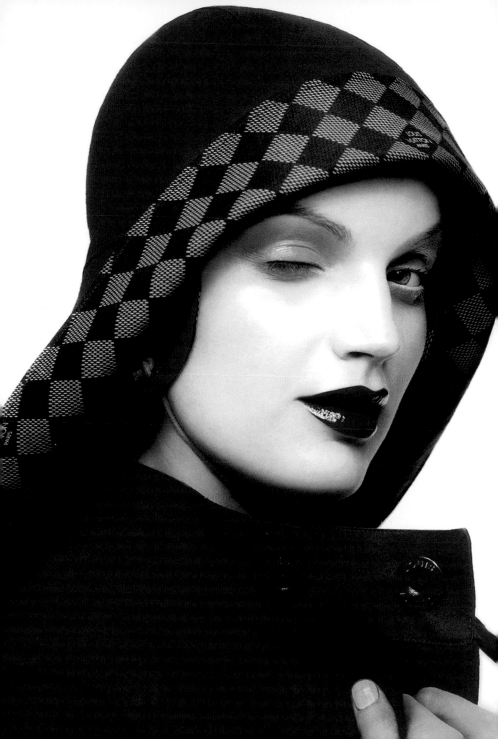

PHOTOGRAPHY BY TESH, STYLING BY EDWARD ENNINFUL. MARCH 2001. MODEL: KATE MOSS

A Stephen Jones hat has the capacity to utterly transform its wearer. His ground-breaking collections are showcased in museums the world over, including the V&A in London, the Fashion Institute of Technology in New York and the Louvre in Paris. Traditional top hats, boaters, military caps, berets and bowlers are cheekily minaturised, unexpected details are added and Schiaparelli-esque twists are highlighted with delightful colour combinations. All of his work is sympathetically in tune with the current fashion climate. Jones (born in 1957) has always had guest-list cool. During the New Romantic era in '80s London he made headwear for friends Steve Strange and Boy George, clients for whom image was everything. In 1984 he conquered Paris when Jean Paul Gaultier and Thierry Mugler invited him to design hats for them. Since then, he has worked with fashion houses including Comme des Garçons, Balenciaga, Hermès and Vivienne Westwood. However his best-known association has been with John Galliano, with whom he celebrated 10 years of collaboration in 2004. Since graduating from Central Saint Martins in 1979 with a BA in fashion design, Jones's creative skills have worked their charm on shoes (he created a collection for Sergio Rossi), postage stamps (for the Royal Mail in England) and kimonos. However hats are his first love and he not only sells a mainline, Model Millinery, from his salon in London, but also produces two diffusion ranges, Miss Jones and Jonesboy, plus accessories including gloves, scarves, sunglasses and bags; in 2004 he created a new hat design for British Airways stewardesses. TERRY NEWMAN

"For me designing is like breathing. It's the editing that's difficult"

PORTRAIT BY PETER ASHWORTH

STEPHEN JONES

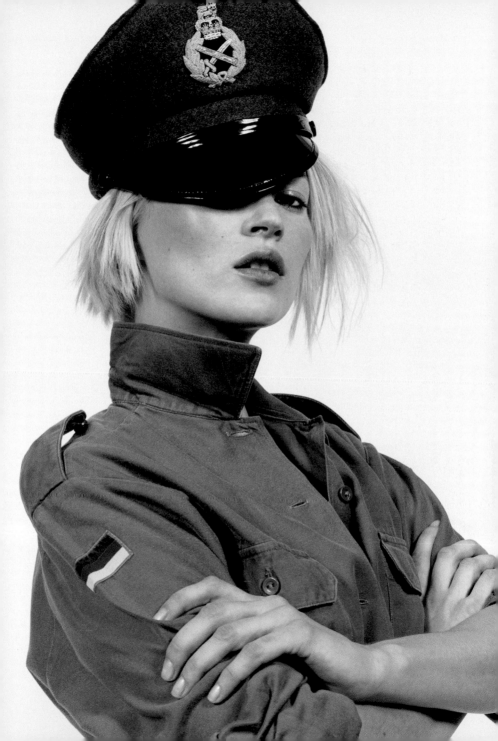

PHOTOGRAPHY BY BARNABY ROPER, STYLING BY DAVID LAMB. OCTOBER 2002

While she was still a student at the Parsons School of Design in New York, Long Island native Donna Karan was offered a summer job assisting Anne Klein. After three years as associate designer, Karan was named as Klein's successor and, following her mentor's death in 1974, Karan became head of the company. After a decade at Anne Klein, where she established a reputation for practical luxury sportswear separates, typically in stretch fabrics and dark hues, Karan founded her own company in 1984 with her late husband, Stephan Weiss. A year later, her highly acclaimed Donna Karan New York Collection, based around the concept of 'seven easy pieces', unveiled the bodysuit that was to become her trademark. Karan's emphasis on simple yet sophisticated designs, including everything from wrap skirts to corseted eveningwear, captured the popular mood of 'body consciousness' that swept Hollywood in the '80s. By 1989, she had expanded this philosophy to the street-smart diffusion line DKNY. In 1992, inspired by the desire to dress her husband, a menswear line was launched. Since then, Donna Karan International has continued to diversify and expand to cover every age and lifestyle, including a children's range, eyewear, fragrances and home furnishings. She has been honoured with an unprecedented seven CFDA awards, including 2004's Lifetime Achievement Award to coincide with her 20th anniversary. The company became a publicly-traded enterprise in 1996 and was acquired by French luxury conglomerate LVMH in 2001 for a reported 643 million US-$. Karan remains the chief designer. MARK HOOPER

"I never see one woman when I design, it's always a universe of women"

PORTRAIT COURTESY OF DONNA KARAN

DONNA KARAN

PHOTOGRAPHY BY SEAN CUNNINGHAM. SPRING/SUMMER 2005

It's hard to imagine a young Francisco Costa growing up in the small Brazilian town where he was born (even to a family already rooted in fashion) and having even an inkling of the career he has now – a career which, in some ways, is only just starting. In the early '90s, the diminutive and cherubic immigrant arrived in New York as bright-eyed in the big city as any who had come before. He set about learning English and enrolled at the Fashion Institute of Technology, where he won the Idea Como/Young Designers of America award. After graduation, he was recruited to design dresses and knits for Bill Blass. But fate soon swept Costa towards his first big break when Oscar de la Renta asked him to oversee the signature and Pink Label collections of his own high-society house, plus Pierre Balmain haute couture and ready-to-wear. In 1998, at Tom Ford's bidding, Costa decamped for the red-hot Gucci studio where he served as senior designer of eveningwear, a position in which he was charged with creating the custom designs for both high-rolling clients and high-profile celebrities. This is where Costa cut his teeth, acquiring the skills required to direct a major label, as he would soon do, returning to New York in 2002 to work for Calvin Klein. Here he assumed the role of creative director of the women's collections, where he remains today. Costa's first marquee Calvin Klein collection was shown in the autumn of 2003, following the departure of the namesake designer (and, as the man who invented designer denim and who, in 1968, founded one of New York's mega-brands, Klein was hardly the easiest act to follow). Costa's debut drew rave reviews across the board for its seamless integration of the label's signature minimalism with a deft vision of how fashion looks now. LEE CARTER

"I really enjoy translating an idea into real product – it's energising"

FRANCISCO COSTA / PORTRAIT COURTESY OF CALVIN KLEIN, INC.

CALVIN KLEIN

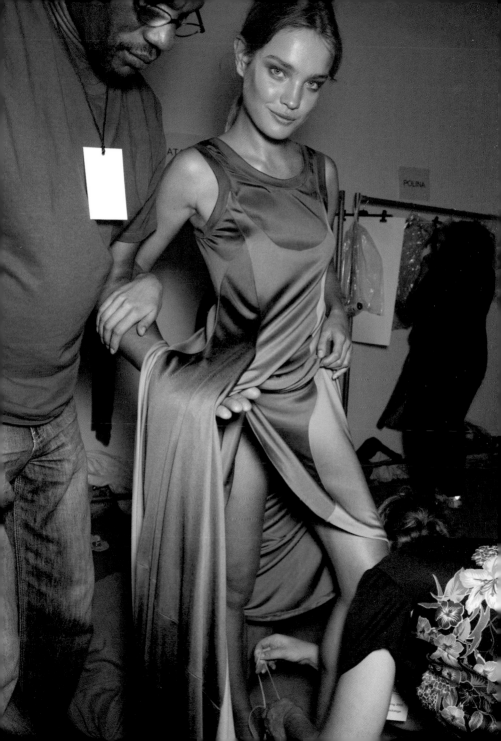

PHOTOGRAPHY BY DAVID DORCICH. SEPTEMBER 2002

Recognised for his fresh, flawless cuts and elegant tailoring, Christophe Lemaire of Lacoste is concerned more with the quality of his lines than with slavishly following trends. With a style he describes as "graphic, pure, relaxed and precise", he captures the balance between fashion and function, creating classic, wearable clothing season after season. Born in Besançon, France, in April 1965, Lemaire initially assisted at the Yves Saint Laurent design studio before going on to work for Thierry Mugler and Jean Patou. Through the Jean Patou house he met Christian Lacroix who was so impressed with the young designer that he appointed him head of his own woman's ready-to-wear line in 1987. Lemaire went solo with his eponymous womenswear label in 1990. His functional designs, with their understated elegance, ensured the label's success and a menswear label followed in 1994. In May 2001 Lemaire became creative director of heritage sportswear brand Lacoste, where he has re-established the company's position on the fashion map. Infusing his own contemporary, sharp style into classics such as the tennis skirt, polo shirt or preppy college jumper, he has attracted new customers while retaining enough of the brand's 70-year-old tradition so as not to lose the old. In June 2001, under his direction, Lacoste staged its first catwalk show. A true fashion DJ, for his own collections Lemaire mixes Western classics with one-of-a-kind ethnic pieces. The result is resolutely modern yet always wearable. "I don't create in a rush," he explains. "I always take time so I can distance myself from things that are too fashionable. As a designer I aim for an accessible balance between beauty and function to create a vision of contemporary 'easy wearing'". HOLLY SHACKLETON

"I find designing actually quite natural and exciting"

CHRISTOPHE LEMAIRE / PORTRAIT BY TERRY JONES

LACOSTE

Christian Lacroix made fashion history with his July 1987 debut couture collection backed by LVMH. His was the first Paris haute couture house to open since Courrèges in 1965. Lacroix took the bustles, bows, corsets and crinolines painted by 18th century artists Boucher, Fragonard and Nattier and mixed them up with ruffles, feathers and fringes of Toulouse-Lautrec's can-can dancers and the gypsies in his hometown Trinquetoulle, Provence. Lacroix's puffball skirt – a taffeta or satin balloon of fabric that gathered a crinoline at the hem – reinvented the ball gown for the late 20th century. "Personally I've always hovered between the purity of structures and the ecstasy of ornament," says the designer who brought Rococo back to couture. Born on 16 May 1956, Lacroix moved to Paris in 1971, where he studied at the Sorbonne and the Ecole du Louvre, where he planned a career as a museum curator. Instead, he began designing, first for Hermès (1978), then Guy Paulin (1980) and Patou (1981) before being offered the keys to his own couture house by Bernard Arnault of LVMH in 1987. Lacroix's inspiration was as broad as Arnault's plans for the label: Cecil Beaton's Ascot Scene in 'My Fair Lady'; Oliver Messel's neo-Rococo interiors; Velasquez Infantas; Lautrec soubrettes; Provencal gypsies and his dynamic wife Françoise. Christian Lacroix ready-to-wear followed the couture in 1998 and diffusion line Bazar arrived in 1994. Lacroix's sensibility translates superbly to theatre, opera and ballet. He designed landmark productions of 'Les Enfants du Paradis', 'La Gaiete Parisienne' and 'Sheherazade' as well as the jewelled corsets worn by Madonna for her 2004 Reinvention Tour. In 2002, Lacroix was appointed creative director of Florentine print house Pucci, and in 2005 a new chapter began for the designer when his fashion house was sold by LVMH to an American company, the Falic Group. JAMES SHERWOOD

"My fashion is more a way of living life with your roots, and finding your own true self, than having a logo to put on your back"

PORTRAIT BY KEVIN DAVIES

CHRISTIAN LACROIX

A legendary name in fashion, Chanel is today synonymous both with its founder, Gabrielle "Coco" Chanel and its artistic director since 1983, Karl Lagerfeld. Chanel herself – who was born in an orphanage, was self-taught and who first established her house in 1913 – is perhaps the most important fashion designer of the 20th century. Her pioneering use of sportswear for high fashion in the '20s, her little black dresses, her costume jewellery, taste for suntanning and appropriation of male dress are the stuff of fashion legend. Her Chanel No. 5 perfume (invented in 1921), is a confirmed 'classic', as are her softly-structured tweed suit and quilted leather handbags (both developed in the '50s). When Chanel died in 1971 she left a rich legacy of house codes which are today boldly reinvented by Karl Lagerfeld. Mademoiselle's favourite pearls turn up, outsized, as little evening bags; tweed is transformed into fluffy leggings and matching berets; a love of the sporty, outdoors life is expressed via Chanel-branded snowboards and surfboards. At Chanel, Lagerfeld heads up one of Paris' few remaining haute couture salons; in July 2002 the company, which is owned by the Wertheimer family, secured the future of its couture business by acquiring five specialist workshops, including Lesage, the prestigious embroidery company. Chanel is today nothing if not a commercial powerhouse and in December 2004 the company opened a multi-floored new store in the Ginza shopping district of Tokyo that includes a restaurant, Beige Tokyo, and a glassy façade fitted with twinkling lights that resemble the brand's famous tweed. In May 2005 the Metropolitan Museum of Art in New York opened an exhibition devoted to Chanel's historic innovations, featuring designs by both the house founder and its present incumbent. Despite this grand heritage, what Coco and Lagerfeld have in common above all is relish for the present times and for the future. As Chanel herself once said, "I am neither in the past nor avant-garde. My style follows life."

SUSIE RUSHTON

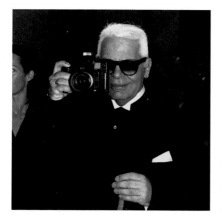

"I am inspired by everything. There is only one rule: eyes open!"

PORTRAIT BY GAUTHIER GALLET

KARL LAGERFELD (CHANEL)

PHOTOGRAPHY BY CRAIG MCDEAN, STYLING BY EDWARD ENNINFUL. OCTOBER 2002. MODEL: AMBER VALETTA

Helmut Lang is simultaneously one of the most influential and one of the most copied designers of the last decade. Starting his label in Vienna in 1977, without any formal training, the Austrian designer (born 1956) showed his first fully formed ready-to-wear collection in Paris in 1986. He was already displaying the shape of things to come: his austere, utilitarian and sportswear-inspired design would go on to dominate the 1990s. Lang formulated the prevailing, stripped-down silhouette of that decade and applied it to both sexes – he was one of the first to show men's and womenswear together. He experimented and introduced techno fabrics to a catwalk style, playing with technology further by showing one collection solely on the Internet, the first designer to do so. While Giorgio Armani is sometimes credited as the father of it and Jil Sander was another early pursuer, it is Lang who fully articulated what has become known as 'minimalism' – a term that he personally doesn't like. Maybe that dislike stems from Lang's almost autobiographical approach to his design: the combination of the formal and the casual at the heart of his aesthetic comes from the strict business suits he was made to wear as a teenager by his step-mother. Rather than 'trends', there is the sense of experimentation within a single identity in his collections. In 1998, Helmut Lang relocated his fashion house to New York. A year later he sold 51 percent of his company to the Prada Group. This has proved the start of a new phase for the designer, with a move into a more 'luxe' aesthetic, together with the launch of a perfume and accessories range.

"I think I always had a good sense of seeing things that were coming and was never afraid to explore them"

PORTRAIT BY ANTHONY WARD

HELMUT LANG

PHOTOGRAPHY BY SOPHIE DELAPORTE, STYLING BY GIANNIE COUJI. SEPTEMBER 2002

Alber Elbaz is the modern romantic who found his perfect match in Lanvin, the Parisian house where he has been artistic director since 2001. His signature designs for the label – pleated silk dresses, satin ribbon details and costume jewellery – are now among the most sought-after in fashion, making his switchback route to success all the more surprising. Elbaz was born in Casablanca, Morocco, and raised in the suburbs of Tel Aviv by his mother, a Spanish artist. His father, an Israeli barber, died when he was young. He studied at the Shenkar College of Textile Technology and Fashion, Tel Aviv, but received some of his most valuable training in New York, where for seven years he was right hand man to the late Geoffrey Beene, couturier to East Coast high society. In 1996, Elbaz was appointed head of ready-to-wear for Guy Laroche in Paris, where he remained for almost three years. In November 1998 he was appointed artistic director for Yves Saint Laurent Rive Gauche, effectively taking over design duties from Saint Laurent himself. In his tenure at YSL, Elbaz attracted a younger clientele – Chloë Sevigny wore one of his dresses to the Oscars. However, at the start of 2000 big business intervened when the Gucci Group took control of YSL Rive Gauche and Tom Ford stepped into Elbaz's position. Following a short but successful spell at Milanese brand Krizia and time out travelling the world, in October 2001 Elbaz returned to French fashion via Lanvin, the couture house founded by Jeanne Lanvin in the 1880s. Under his direction, Lanvin has developed jewellery, shoe and handbag collections. His most outstanding talent however is for the creation of ultra-feminine cocktail dresses that are the epitome of Parisian chic. In 2005, he won the CFDA's International Award. Fashion's favourite come-back kid, Elbaz also wears bow ties very well. SUSIE RUSHTON

"I want to re-introduce fragility and emotion to fashion, my way"

ALBER ELBAZ / PORTRAIT BY ROBERTO FRANCKENBERG

LANVIN

PHOTOGRAPHY BY WILLY VANDERPERRE, STYLING BY OLIVIER RIZZO. AUGUST 2002

Ralph Lauren (born 1939) is a household name. Jamaica has even issued a commemorative stamp (in 2004) featuring Lauren. The man and his brand's logo of a polo player riding a horse is recognised by all. From a $50,000 loan in 1968, Polo Ralph Lauren's humble beginnings grew into the internationally famous lifestyle brand which everyone knows today. Lauren was one of the first designers to extend his production of clothing lines to house-ware and furniture. He was also the first of the megabrand American designers to set up shop in Europe, in 1981; the Polo Ralph Lauren Corporation now has 280 stores in operation globally and its collections are divided into myriad different labels. In October 2004 in Boston the company opened its first Rugby store, a lifestyle collection for the 18-to-25 year-old men and women. The Rugby line joins Lauren's other collections, Purple Label (1994), Blue Label (2002) and Black Label (2005). Underpinning Lauren's designs is an unmistakable preference for old-world gentility. In fact, he has made the Ivy League, preppy style his own. "I don't want to be in fashion – I want to be a fashion," he once told Vogue magazine. And indeed, the Ralph Lauren look is distinctive, nowhere more purely expressed than in his advertising campaigns that always feature a cast thoroughbred models, often posed as if holidaying in the Hamptons. Lauren's entrance into fashion can be traced back to 1964 with Brooks Brothers, and then Beau Brummell Neckwear in 1967, where he designed wide ties. In the following year, the beginnings of what was to become a billion dollar brand took root. The Polo menswear line was launched and in 1970 he won the Coty Menswear Award; Lauren added womenswear to the brand in 1971. He has been awarded the CFDA's Lifetime Achievement Award (1992) along with its menswear designer (1995) and Womenswear designer (1996) prizes. Lauren is also involved in philanthropic activities. The Polo Ralph Foundation organises campaigns such as Pink Pony (2000), which supports cancer care and medically underserved communities. KAREN LEONG

"I believe in style, not fashion"

PORTRAIT COURTESY OF RALPH LAUREN

RALPH LAUREN

PHOTOGRAPHY BY CHRISTOPHE RIHET, STYLING BY HAVANA LAFFITTE. NOVEMBER 2002

Véronique Leroy (born 1965) has never toed the party line. Born and brought up in the industrial Belgian city of Liège, a 19-year-old Leroy decided to complete her training in Paris, at Studio Berçot, while most of her compatriots studied at Antwerp's Royal Academy. The designer has been at home in the French capital ever since. After assisting Parisian legends Azzedine Alaïa and Martine Sitbon, Leroy launched her solo line in 1991. From the beginning, it possessed what was to become her signature: juxtaposition – in this case, tailored high-waisted trousers and dandified satin shirts. Leroy creates clothes that women want to wear while also catching the eye of their partner; they are sexy and intelligent without becoming either trashy or scary. Devoted female fashion insiders now follow her every collection and she is laden with prizes for her work, winning the Vénus de la Mode prize for 'Le Futur Grand Créateur' no less than three times. Forever defying categorisation, Leroy continues to find her own way through the fashion jungle. Accompanying her on the expedition are her long-time collaborators and close friends, the photographic team Inez van Lamsweerde and Vinoodh Matadin, who have helped develop the look of the label. Each collection plays out an obsession with the female form. Structural distortion, subtle erogenous zones and layering of sensuous fabric have been used to celebrate women's bodies, while unlikely inspirations include wrestlers and 'Charlie's Angels'. Leroy has also been involved in fruitful collaborations. She recently produced a capsule denim collection for Levi's and her work with print maestro Léonard since 2001 has become an outlet for her distinctive graphic talents. LAUREN COCHRANE

"Making clothes isn't exciting – but what is exciting is being able to give them soul"

PORTRAIT BY KARL LAGERFELD

VÉRONIQUE LEROY

PHOTOGRAPHY BY STEEN SUNDLAND, STYLING BY JAMES SLEAFORD. NOVEMBER 2000

"I'd much rather be forever in blue jeans," sang Neil Diamond in 1978. Almost 30 years later, Diamond's words echo the thoughts of a jeans-obsessed world. 2003 saw the 130th anniversary of the birth of blue jeans and 150 years since the founding of Levi Strauss & Co. As American as apple pie and Dolly Parton, Levi Strauss was created by San Francisco trader Strauss and a Reno tailor called Jacob Davis who bought his denim from Strauss. Davis riveted trousers for a client who complained that his tore too easily, and when other customers asked for the same service he decided to patent the idea with the financial backing of Levi Strauss. In 1873 the first 'patented riveted overall' was produced, featuring the still-famous double arc pockets. Fast forward over 100 years and Levi's iconic TV advert starring Nick Kamen taking off his Levi's in a launderette (1985) helped to revive the flagging reputation of denim, increasing sales of the 501 jeans by 820 per cent. Other memorable Levi's ads include mermaids in 1997, Flat Eric in 1999 and a bunch of kids with mouse heads in 2004. In the late '90s and into the new millennium, denim continued in popularity and the number of companies competing for the jeans-buying customer's attention is no longer restricted to heavyweights like Levi's, Lee and Wrangler. Levi's response to this has been to introduce various new iconic jeans shapes. The Levi's Red range introduced the successful twisted leg in 1999, while 2003 saw the launch of the Type 1, and in 2004, the Anti-Fit 501. 150 years after their creation, Levi's jeans are a powerful symbol of popular dress culture in the 20th century and beyond. Gary Harvey is creative consultant for Levi's Europe, having previously been creative director of the brand for five years. STEVE COOK

"Clothing is a subliminal language that communicates how you want to be perceived."

GARY HARVEY, CREATIVE DIRECTOR LEVI'S EUROPE, MIDDLE EAST & AFRICA
PORTRAIT COURTESY OF GARY HARVEY

LEVI'S

PHOTOGRAPHY BY CORINNE DAY, STYLING BY KARL PLEWKA. AUGUST 2001

"I don't want to be avant-garde," says Julien Macdonald of his upfront brand of showgirl glamour: "I like beautiful clothes. I don't care what people think about me." Macdonald's love for fashion was inspired by the knitting circles his mother held at home in the Welsh village of Merthyr Tydfil. Studying fashion textiles at Brighton University, his sophisticated knitwear went on to win him a scholarship at London's Royal College of Art. By the time he graduated in 1996, with a spectacular collection styled by Isabella Blow, he had already designed for Koji Tatsuno, Alexander McQueen and Karl Lagerfeld. Lagerfeld spotted Macdonald's knits in the pages of i-D and appointed him head knitwear designer for Chanel collections in 1997. Utterly devoted to the female form, Macdonald reinvigorated knitwear with his glitzy red-carpet creations. His barely-there crochet slips of cobwebs and crystals, shocking frocks and furs guarantee headlines for a devoted throng of starlets and celebrities. Macdonald's catwalk antics – including appearances from the Spice Girls and a Michael Jackson lookalike, plus an autumn/winter 2001 presentation held at the Millennium Dome and directed by hip-hop video supremo Hype Williams – have earned him a reputation as a showmaster. After being crowned the British Glamour Designer of the Year for the first time in 2001 (an award he picked up again in 2003) Macdonald went on to take his high-octane street-style to couture house Givenchy, where he succeeded Alexander McQueen as creative director. Under his direction, sales for the luxury label increased despite some mixed reviews from fashion critics, and with three years under his belt he produced an acclaimed farewell show for autumn/winter 2004. For now, Macdonald continues to present his flamboyant collections in London, where he also oversees his homeware, fragrance and high street lines.

JAMIE HUCKBODY

"Ultra-sexy, ultra-glamourous, sparkly and short: that sums up what I do"

PORTRAIT BY CORINNE DAY

JULIEN MACDONALD

PHOTOGRAPHY BY BARNABY & SCOTT, STYLING BY GIANNIE COUJI. OCTOBER 1999

Since establishing the label in 1994 Hardy Blechman has cultivated Maharishi beyond a stock streetwear label and into a thriving creative empire. From importing surplus clothing into the UK to gaining international notoriety for the 'Snopant' trousers in 1995, Blechman (born in Bournemouth in 1963) has bypassed the traditional methods of formal design and has maintained Maharishi as a privately-owned company with a unique ethos and environmental concerns at the heart of its business. Specialising in the use of hemp and natural fibres and drawing on the creative input of artists such as graffiti legend Futura 2000, Maharishi has created consistently innovative collections for men, women and children. 2001 saw the opening of the conceptual flagship store in Covent Garden, London. The space was developed to house each strand of the business from the Mhi clothing range to non-violent toys (in particular figurines of Warhol and Basquiat). The space mirrors the thinking behind the clothes – a combination of technical structuralism and the freedom of nature. Sticking to his roots Hardy has acknowledged the influence of camouflage with the recent publication of DPM (Disruptive Pattern Material), an encyclopaedic book charting the history of camouflage. In fact, camouflage has been a central trademark of Blechman's design. The military-issue textile is reinterpreted to create designs beautiful in their own right, taking influence from nature and art with tiger stripes and Warhol-inspired bright coloured prints. With such a strong foundation it is hard to imagine that Maharishi will continue to be anything other than one of the most innovative brands around.

WILL FAIRMAN

"I am inspired by figures who encourage radical rethinking"

HARDY BLECHMAN / PORTRAIT BY MARK LEBON

MAHARISHI

Martin Margiela is the fashion designer's fashion designer. Normally this comment could be read as a casual cliché, but in the case of Margiela it is justified. For unlike any other designer, he produces work which could be seen as a distinct form of 'metafashion': his clothes are essentially about clothes. With his own peculiar yet precise vision, he is one of the most influential and iconoclastic designers to have emerged over the past fifteen years. Born in 1959 in Limbourg, Belgium, he studied at Antwerp's Royal Academy and was part of the first wave of talent which would emerge from the city. Between 1984 and 1987 he assisted Jean Paul Gaultier; in 1988, Maison Martin Margiela was founded in Paris and his first womenswear collection, for spring/summer 1989, was shown the same year. Struggling to come to terms with a definition of Margiela's fashion, with its exposure of and mania for the process and craft of making clothes, the press labelled this new mood 'deconstruction'. Eschewing the cult of personality that attends many designers, Martin Margiela has instead fostered a cult of impersonality. Never photographed, never interviewed in person or as an individual ('Maison Margiela' answers faxed questions), even the label in his clothing remains blank (as in the main womenswear line) or simply has a number circled ('6' for women's basics and '10' for menswear). In 2000, the first Margiela shop opened in Tokyo, followed by stores in Brussels, Paris and London, and three further shops in Japan. From 1997 to 2003, in addition to his own collections, Margiela designed womenswear for Hermès, and in July 2002, Renzo Rosso, owner and president of the Diesel Group, became the major shareholder in Margiela's operating group, Neuf SA, allowing the company further expansion. Margiela has also participated in numerous exhibitions and in 2004 curated 'A' Magazine.

JO-ANN FURNISS

"To evolve is to continue to breathe creatively"

MARTIN MARGIELA / PHOTOGRAPHY BY MICHEL MOMY

MAISON MARTIN MARGIELA

PHOTOGRAPHY BY STEFANO MORO, STYLING BY CHRISTINE FORTUNE. AUGUST 2002

Since 2003 Antonio Marras has been in the limelight as artistic director of womenswear for Kenzo – an appointment, perhaps, that reflects the sense of tradition that was so important to Kenzo Takada when he was designing his eponymous line. Although Marras's first collection under his own name was launched as recently as 1999, with 2002 seeing his first men's ready-to-wear collection, he is already established as an international designer in his own right. He remains firmly based in his native Sardinia, working with his extended family in Alghero, where the locality and culture have a strong influence on his design. It is here that Marras (born 1961) pulls together his cut-and-paste aesthetic. This is characterised by his high standard of craftsmanship (laborious and highly detailed embroidery), random destruction (holes burned in fine fabrics), extravagant brocades sitting cheek-by-jowl with an unfinished hem, deconstructed shapes with vintage fabrics and a wide repertoire of what Marras calls "mistreatments": tearing, matting, staining, encrusting with salt, and so on. Marras takes this approach to its logical conclusion, creating a range of off-the-peg one-offs made from the material scraps saved in making his main line, the kind of scraps he grew up surrounded by in his father's fabrics shop. Lacking any formal training, it took a Rome-based entrepreneur to spot Marras's potential, allowing him to launch a career as a designer in 1988. That same year he won the Contemporary Linen Prize for a wedding dress and worked freelance for a number of companies whose collections he infused with his love of Mediterranean costume. Certainly, handcrafting is where Marras's heart lies and his philosophy of mend and make-do is applied to all the collections he designs. JOSH SIMS

"Every single piece is a piece of my heart"

PORTRAIT BY CRICCHI & FERRANTE

ANTONIO MARRAS

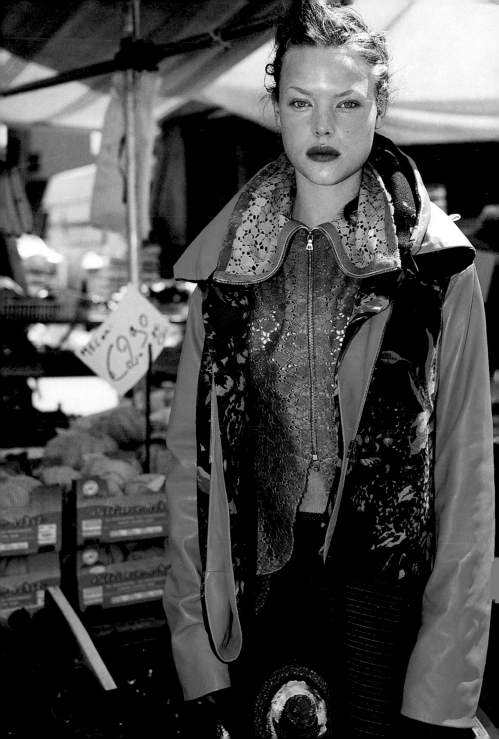

PHOTOGRAPHY BY ALASDAIR MCLELLAN, STYLING BY SORAYA DAYANI. OCTOBER 2002. MODEL: JAYNE WINDSOR

Stella McCartney's stratospheric success story has only a little to do with her fabulous connections. Born in 1971, she graduated from Central Saint Martins in 1995. Her final year collection was snapped up by the biggest names in retail (including Browns and Bergdorf Goodman) and a mere two years later her sharp-tailoring talents landed her the top job as creative director at Chloé. Trouser suits, vintage-inspired dresses and jet-setting holidaywear are trademark Stella-style. Her designs are often also possessed of that rarity in the fashion world, an exuberant sense of humour (folk went bananas over her fruity vests and knickers). In 2001 McCartney left Chloé and re-launched her own eponymous line, this time backed by the Gucci Group. The first Stella McCartney store opened in New York's meatpacking district in 2002, followed a year later by additional shops in London and Los Angeles. 2004 saw the girl with the golden touch honoured with a Designer of the Year award in London. Like her late mother Linda, she is serious about animal rights and refuses to use leather or fur in any of her designs. She also received a Women of Courage Award for her work with cancer charities. Whether working on experimental projects (such as the collaboration with artist Gary Hume in 2002 to produce handmade T-shirts and dresses), designing costumes for Gwyneth Paltrow's action movie 'Sky Captain' (2004) or enjoying the mainstream success of her perfume, McCartney is forever working a new angle. Summer 2005 saw her latest project unveiled, a new collection of keep-fit wear designed in conjunction with Adidas, with a special collection for H&M launched later the same year.

TERRY NEWMAN

"I represent something for women. I've built up trust with them and that's important"

PORTRAIT BY KAYT JONES

STELLA MCCARTNEY

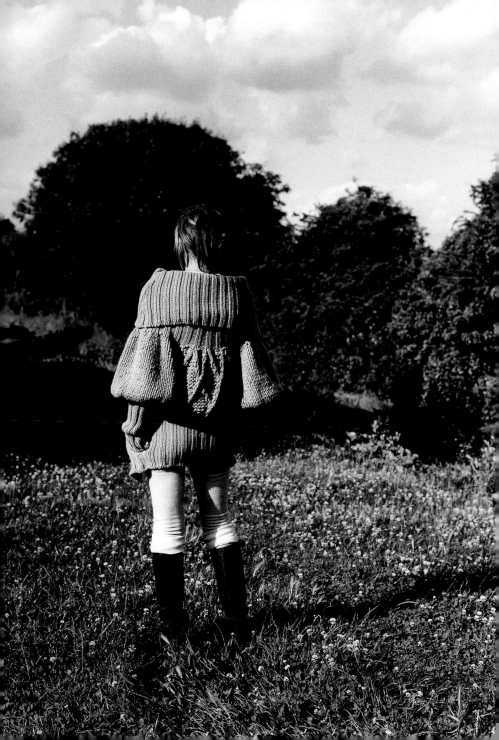

PHOTOGRAPHY BY STEVEN KLEIN, STYLING BY EDWARD ENNINFUL. SEPTEMBER 2002. MODEL: JAMIE BOCHERT

The Gothic sensibility of a Brothers Grimm fairytale is closer in spirit to Alexander McQueen's clothing than the fetish, gore and misogyny he's been accused of promoting. However dark McQueen's design, it still achieves a femininity that has seduced everyone from Björk to the Duchess of Westminster. McQueen's rise to power is a fashion fairytale all of its own. The East End taxi driver's son, born in 1969, is apprenticed to the Prince of Wales' tailor Anderson & Sheppard on Savile Row where he infamously scrawls obscenities into the linings of HRH's suits. He works with Romeo Gigli, theatrical costumers Angels & Bermans and Koji Tatsuno before Central Saint Martins MA course director Bobby Hilson suggests he enrol. His 1992 'Jack the Ripper' graduation collection thrills members of the British fashion press, none more so than Isabella Blow who buys the entire collection and adopts McQueen as one of her protégés. McQueen's bloodline of angular, aggressive tailoring is inherited from MGM costume designer Adrian, Christian Dior and Thierry Mugler. His 'Highland Rape' and 'The Birds' collections used Mr Pearl corsetry to draw in the waist and exaggerate square shoulders and sharp pencil skirts. Brutality tempered by a lyricism characterises the McQueen style. By 1996 he was named British Designer of the Year. 1996 also saw McQueen replace John Galliano as head of Givenchy haute couture. But by 2001 the Gucci Group had acquired a controlling stake in McQueen's own label and the designer left both Givenchy and LVMH. Since then, McQueen's eponymous label has dazzled Paris with bittersweet theatrical presentations. 2003 saw the launch of his first perfume, Kingdom, and a bespoke menswear collection produced by Savile Row tailor Huntsman; in 2004 his men's ready-to-wear was shown in Milan for the first time. JAMES SHERWOOD

"There is still a lot I want to achieve. There isn't any room for complacency in this head!"

PORTRAIT BY CORINNE DAY

ALEXANDER MCQUEEN

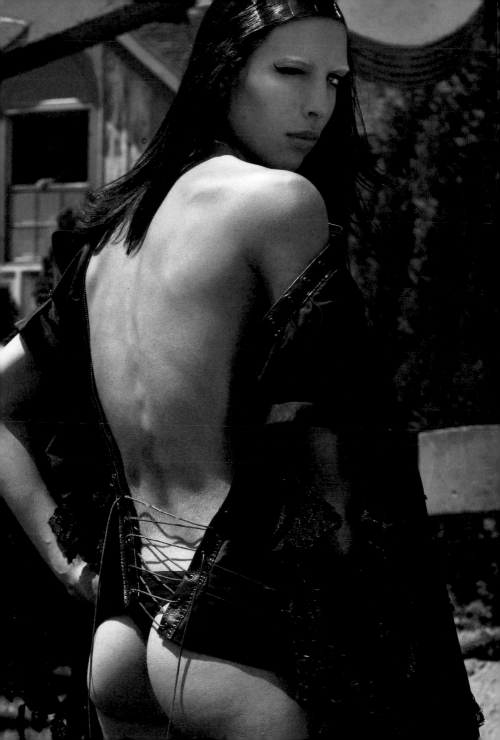

PHOTOGRAPHY BY PETE DRINKELL, STYLING BY RACHAEL ZILLI. APRIL 2002

With a history that spans over 50 years, the house of Missoni is that rare phenomenon in fashion, an enduring force to be reckoned with. Established in 1953 by Rosita and Ottavio Missoni, what began as a small knitwear factory following the traditional Italian handicraft techniques has evolved into a world – famous luxury label whose technical innovation and free-thinking approach have redefined notions of knitwear. A fateful meeting with Emmanuelle Khanh in Paris resulted in an important early collaboration and the first Missoni catwalk show took place in Florence, in 1967. By 1970, the Missoni, fusion of organic fabrics, a mastery of colour and instantly recognisable motifs – stripes, zig-zags, Greek keys and space-dyed weaves – saw the house become the last word in laid-back luxury. The layered mismatching of pattern and colour, mainly in the form of slinky knits, has become synonymous with Missoni inspiring the American press to describe the look as "put-together". Since taking over design duties in 1997, Angela Missoni has imaginatively updated the brand, introducing florals and even denim without losing the essence of classic Missoni. After working alongside her mother Rosita for 20 years, in 1993 Angela produced her own collection, becoming Missoni's overall creative director when her parents retired a few years later. Angela has subtly transformed the beguiling feminine looks of the Missoni archive with tailored lines and sassy slim-line silhouettes. Missoni has stood the test of time by attracting a new generation of devotees whilst maintaining the kudos of cool it established during its '70s heyday. Constantly referenced by the mass market, the Missoni style sits as happily on the red carpet as it does in the wardrobe of modern day bohemians.

AIMEE FARRELL

"I grew up with my parents' work"

ANGELA MISSONI / PORTRAIT COURTESY OF ANGELA MISSONI

MISSONI

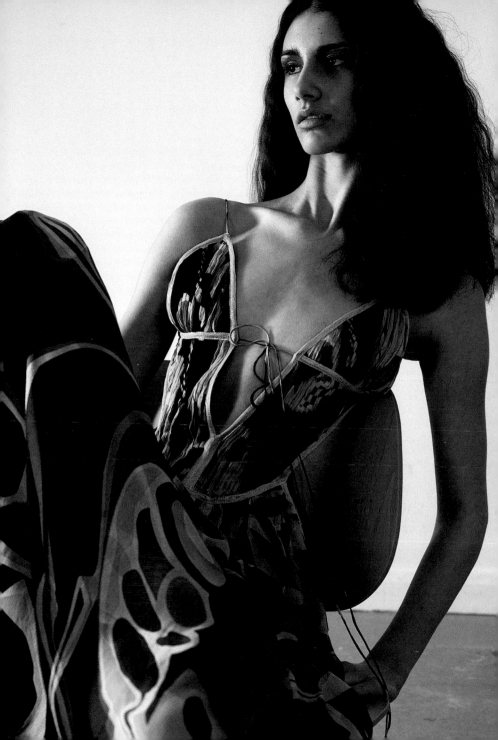

PHOTOGRAPHY BY JEREMY MURCH, STYLING BY NICK GRIFFITHS. JANUARY/FEBRUARY 1998

Issey Miyake (born Hiroshima, 1938) was one of the first Japanese designers to show on the European catwalks in 1973, almost a full decade before Yohji Yamamoto and Comme des Garçons. After studying graphic design at Tama Art University, Miyake moved to Paris in 1964, working for Guy Laroche and Hubert de Givenchy. Before returning to Tokyo to set up his own company, Miyake Design Studio, he also worked for Geoffrey Beene in New York. Each affected Miyake's work as a designer: Beene with his subtlety of form, Laroche and Givenchy with their distinctly Parisian sense of cut and structure. However, Miyake's own collections were something entirely new. He was the first to marry Japanese design with that of the West: aside from looking at the textures and dyeing of traditional Japanese fabrics (such as farmers' smocks), he also utilised some of the notions of Japanese dress, such as universal sizing. This fitted well with his desire to create practical and democratic clothing; a universality later expressed through his choice of models – a show in 1976 used all black girls, another cast women in their 80s. Miyake's designs immediately received acclaim beyond the fashion world and in 1986 he started collaborating with the photographer Irving Penn, who has created an impressive body of work that clearly visualises Miyake's ideas. Besides his own-name label (designed by Naoki Takizawa since 1999), Issey Miyake also produces a line of entirely pleated clothing, Pleats Please, and the collection (designed with his assistant, Dai Fujiwara) he now dedicates his time to, A-POC (A Piece Of Cloth). A genuinely new way of constructing clothes, thread is fed into a knitting machine, creating a 3-D tube of fabric with demarcation lines that, when cut, form a complete wardrobe from large dresses to a simple pair of socks. A-POC was first seen at the Paris collections in October 1998, when 23 models appeared on the catwalk all connected by a piece of cloth. The technique is a closely guarded secret at the Miyake Design Studio, with a patent pending.

"I am a part of my past, but I look to the future"

PORTRAIT COURTESY OF ISSEY MIYAKE

ISSEY MIYAKE

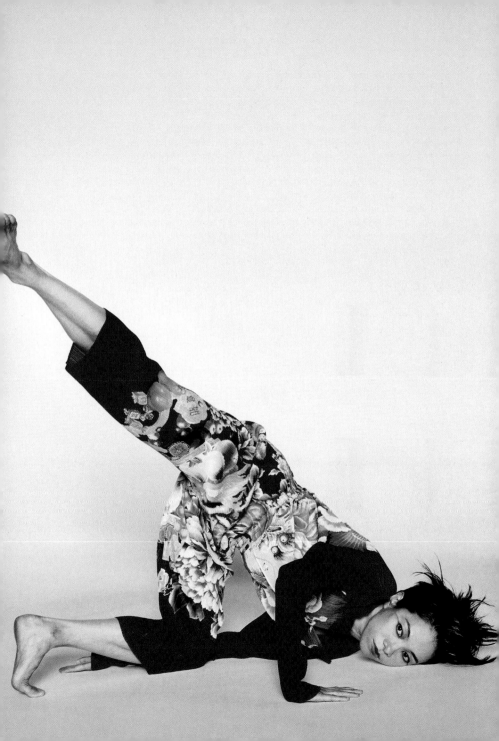

PHOTOGRAPHY BY SATOSHI SAIKUSA, STYLING BY HAVANA LAFFITTE. MAY 2004. MODEL: DARIA

Rossella Tarabini (born 1968), daughter of the Blumarine designer Anna Molinari and designer of the collection that takes her mother's name, has an affinity with London. Its street life, the punks on the Kings Road in the '70s, and glamorous Mayfair nights all served as inspiration for her autumn/winter 2005 collection. Tarabini's creations are a mirror to her interests and experiences, and each of her collections tells a story, whether it be of a Russian princess or a rock singer. Her designs range from flirty florals to sophisticated chic – sometimes laced with a darker edge – in chiffon, ruching and lace. Overall, the line has a more eclectic and experimental feel in comparison to the more established Blumarine label. Born in Carpi, Italy, Tarabini is the eldest daughter of Anna Molinari and her husband Gianpaolo Tarabini. When she was nine years old, her mother and father started Blumarine. Raised in the world of fashion, it was only natural that she should follow in her mother's footsteps. Tarabini studied arts at Modena's Liceo Linguistico before going to Bologna University. In 1994, after a stay in London, she started working on the Blumarine ad campaigns as an art director. The following year, aged just 26, she began to design a new collection for the family-run fashion house, named Anna Molinari. Recently, Tarabini has resumed her former role as art director of the Blumarine campaigns, while continuing to work on Anna Molinari and another of the company's ultra-feminine brands, Blugirl. KAREN LEONG

"I believe in the power of contradiction"

ROSSELLA TARABINI / PORTRAIT COURTESY OF ANNA MOLINARI

ANNA MOLINARI

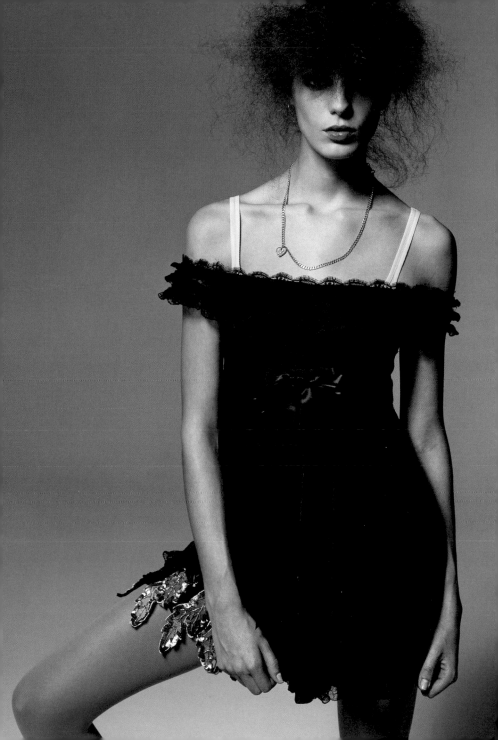

PHOTOGRAPHY BY MISCHA RICHTER, STYLING BY FIONA DALLANEGRA. AUGUST 2001

Hamish Morrow was born in South Africa in 1968, eventually moving to London in 1989 to study fashion at Central Saint Martins. Due to financial problems, however, he was forced to quit the course, thereafter undertaking freelance design and pattern cutting work until 1996, when he began further studies at the Royal College of Art. From here he obtained an MA in menswear, which subsequently helped secure him employment. This included designing for Byblos in Milan and stints at other design houses in Paris and New York. In 2000 Morrow returned to London and began working on the launch of his eponymous line. By 2001, his collection for autumn/winter of the same year, 'The Life Cycle of An Idea', was shown off-schedule (the presentation also featured flowers in various stages of decay) and earned him rave reviews. Continuing to uphold an intelligent, conceptual approach to his designs – far removed from more flashy, celebrity-endorsed forms, of which he has expressed his dislike – Morrow has since become a force to be reckoned with. His eponymous collections are infused with sensibilities that might be culled from high art or cutting-edge music, always with an eye for exquisite fabrics and adventurous cutting. Morrow has collaborated with various internationally-renowned design houses, including Fendi, Krizia and Louis Féraud. He has also produced capsule collections for British mass market chain Topshop over the past two years and, for autumn/winter 2004, created a collection of denim and metallic textiles for online retailer Yoox.com. Morrow's experience-rich CV, quiet determination and undeniable talents would seem to ensure his future success.

JAMES ANDERSON

"I'm inspired by ideas, their evolution and the future"

PORTRAIT BY DENNIS SCHOENBERG

HAMISH MORROW

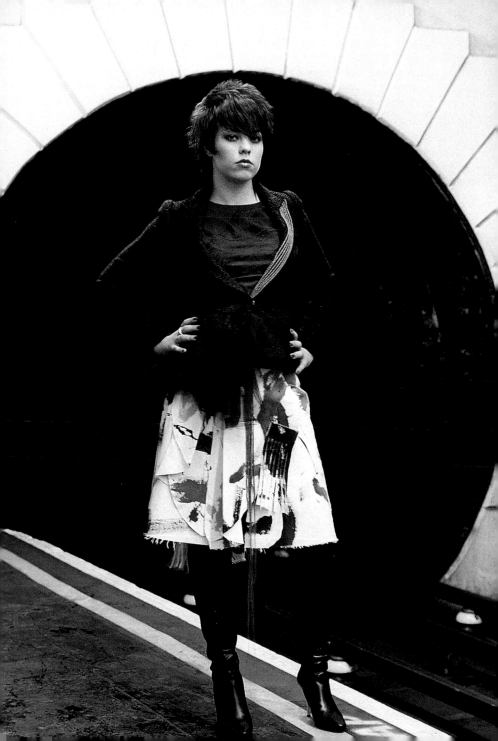

PHOTOGRAPHY AND STYLING BY JASON EVANS. JULY 2001

The Italian fashion house Moschino owes much to Rossella Jardini who, since the untimely death of its founder Franco Moschino in 1994, has successfully held the reins of a brand which today still puts the kook into kooky. Moschino, having burst onto the scene in 1983, has grown up since its logo-mania '80s heyday (remember phrases like 'Ready To Where?' or 'This Is A Very Expensive Shirt' splashed onto garments?). But Jardini, as creative director of all Moschino product lines (sold through 22 shops worldwide), has steered this label in a contemporary direction while retaining its traditional wit. Since the millennium we have seen Jardini and her team continue to tease the market through parody and stereotype, both of which are central to the original philosophy of the house. Rompish catwalk parades featuring housewives in curlers and sleeping masks, demure '50s ladies à la Chanel (one of Jardini's most important personal influences), over-the-top prints, trompe l'oeil and swishy petticoats have all provided gleeful style moments. Born in Bergamo in 1952, Jardini began her career selling clothes rather than designing them. Then, in 1976, she met Nicola Trussardi and began assisting with the development of that company's clothing and leather goods. Creating her own line in 1978 with two model friends, she soon made the acquaintance of Franco Moschino and in 1981 began assisting him. A stint designing accessories for Bottega Veneta followed, but by 1984 she had settled into a permanent role at Moschino. Ten years later, before his tragically early death, Franco Moschino made it quite clear he wished Jardini to take over the helm. She has been there ever since. SIMON CHILVERS

"My ultimate goal is always to improve on the last collection"

ROSSELLA JARDINI / PORTRAIT COURTESY OF ROSSELLA JARDINI

MOSCHINO

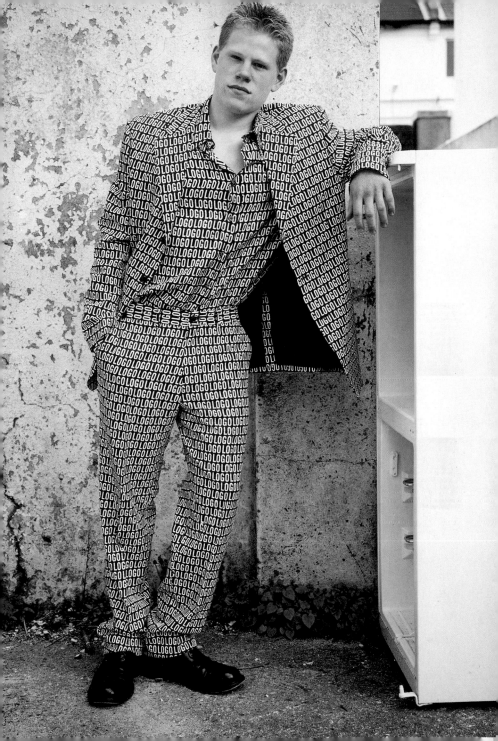

PHOTOGRAPHY BY SEAN CUNNINGHAM. SPRING/SUMMER 200.

When Roland Mouret (born 1961) set up his label in 1998, he was no newcomer to fashion. Then aged 36, the butcher's son from Lourdes had previous experience as a model, art director and stylist in Paris and London. While Jean Paul Gaultier, Paris Glamour and i-D are namechecked on his stylist CV, he had little experience of making clothes, with only two years at fledgling label People Corporation under his belt. His first collection of fifteen one-off pieces threw the need for patterns out of the window. Instead, the critically acclaimed garments were put together using skilful draping and strategically placed hatpins. While his method may have become more refined with subsequent collections, Mouret's motto remains the same: "It all starts from a square of fabric". Inspired by folds, Mouret makes staggeringly beautiful clothes with the minimum of fuss. This formula has been hugely successful. His label is stocked all over the world in high profile stores including Harrods and Bergdorf Goodman. As well as the clothing line, it now includes rough diamond jewellery line RM Rough and the recently introduced cruise collection. Since 2003, the London-based designer has chosen to show in New York and such a move has seen more Mouret on the red carpet. The fashion world is just as devoted as his celebrity clientele. Mouret's work has been acknowledged with a Vidal Sassoon Cutting Edge award and the Elle Style Awards named him British Designer of the Year in 2002.

LAUREN COCHRANE

"My ultimate goal is to build a fashion house that outlives me"

PORTRAIT BY KEVIN DAVIES

ROLAND MOURET

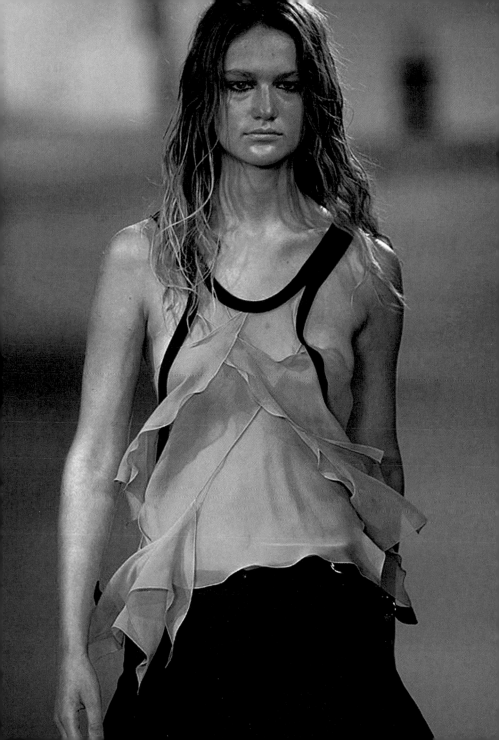

PHOTOGRAPHY BY ROBERT WYATT, STYLING BY LUCY EWING. FEBRUARY 2002. MODEL: KIRSTEN OWEN

Jessica Ogden (born 1970) is an exceptional figure in fashion for many reasons. She makes her samples in a size 12. She has often shown her collections on 'real' women rather than models. She is completely self-taught. And she is a true original. The daughter of a commercials director and a model-turned-curator, the Jamaican-born Ogden had global potential from birth. She studied as a teenager at the Rhode Island School of Design in the US before moving to London in 1989 to study sculpture at Byam Shaw School of Art. It was while in London that her fashion career blossomed under somewhat unconventional circumstances. Working as a volunteer for Oxfam's NoLogo project, Ogden re-worked other people's cast-offs into new, original and desirable garments. Realising she was onto something, Ogden set up her own label in 1993. Revitalising vintage textiles has occupied her ever since, often in the form of patchwork, which is a recurring theme. Fittingly for an ex-sculptor, texture is also important in Ogden's work. By manipulating the structure of a garment's fabrics, she makes clothes that also function as new, abstract forms. Such experimentation has endeared her to legions of Japanese fans, celebrities like Sofia Coppola and institutions including the Crafts Council and the Design Museum in London. Her work has also been exhibited in Antwerp, Tokyo and Prague. Besides hand-me-downs, her inspirations include her Jamaican roots. Spring/summer 2005's collection dipped into the colours, music and atmosphere of island life after a visit home to take part in Caribbean Fashion Week. Ogden has also collaborated with French label APC since 2001, creating a children's collection and, more recently, a resort line inspired by Indian textiles named 'Madras'. LAUREN COCHRANE

"Clothes are about much more than just cloth. It's giving the wearer something more than a garment. It's transferring emotion"

PORTRAIT BY JOHN SPINKS

JESSICA OGDEN

PHOTOGRAPHY BY DUC LIAO, STYLING BY KANAKO B KOGA. SEPTEMBER 2002

José Enrique Oña Selfa has an aesthetic fetish for sado-masochistic strictness. His muse is the nun, the Latin widow, the horse rider, the Latino dancer. Discipline lubricated by delicious torture is what floats Oña Selfa's fashion boat. Born in 1975, his parents are from Andalusia, Southern Spain, and moved to Brussels in the 1960s, where Oña Selfa was raised. He studied fashion at the Ecole Nationale Supérieure des Arts Visuels de la Cambre, graduating in 1999 with a Masters of the highest distinction. By that point he had already been working with fellow student Olivier Theyskens for two years, assisting him as a pattern cutter and knitwear designer when Theyskens dropped out to launch his own label. Oña Selfa started his own company in 2000, presenting a debut show for autumn/winter to international acclaim. The collection featured directional and revolutionary knitwear that was very much a product of Oña Selfa's mixed heritage, the fusion of passionate Latin energy and brooding Belgian romance. Sex sells and Oña Selfa's aesthetic had the cut and thrust that Loewe, a relatively unknown label compared to LVMH's other brands, was looking for. (Other womenswear designers for Loewe have included Karl Lagerfeld, Giorgio Armani and Narciso Rodriguez.) Despite his relatively short career history, he was hired as the company's new designer. Like Helmut Newton bullfighting infantas, girls stormed in at Oña Selfa's first Loewe collection for autumn/winter 2002 in his mix of bourgeoise luxury and high voltage sexual energy crafted in the house fabric: Nappa leather. Sex has seldom looked so expensive. Oña Selfa also continues to show his own collection in Paris.

"I love the essence of women"

PORTRAIT BY DUC LIAO

JOSÉ ENRIQUE OÑA SELFA

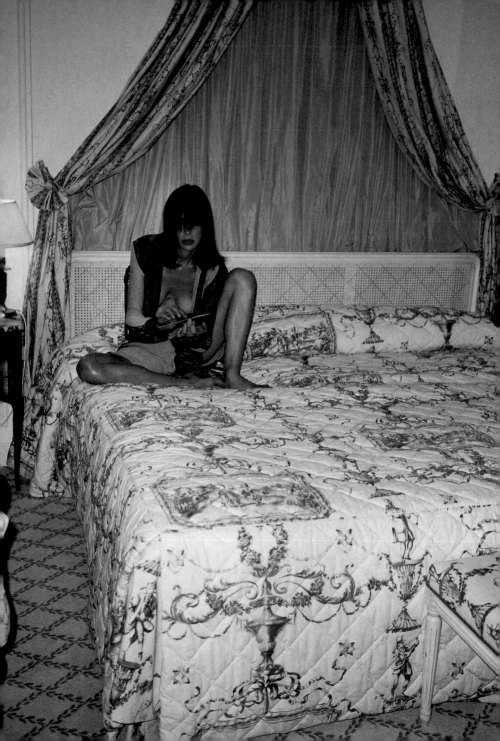

PHOTOGRAPHY BY ALEX HOERNER. MAY 2002. MODEL: MICHELE LAMY

Rick Owens (born 1961) stands alone in the international fashion industry. He is that rare thing: an LA designer. Owens' draped, dark, and perfectly-cut aesthetic is the antithesis of the sunshine-saturated, bleached-teeth image of LA. Born in the city, Owens grew up in Porterville, a small town in California. Moving back to LA in 1984 after high school, he studied painting at the Otis Parsons Art Institute, but dropped out after two years and began to pursue his career in fashion. However he rejected fashion college and instead studied pattern cutting at a trade school. In 1988 he took a job in LA's garment district, where he earned his keep as a pattern cutter for six years. In 1994, Owens set up his own label and began selling his small collections through Charles Gallay, an up-and-coming boutique. Nineties pop culture and Hollywood's red carpet influenced his designs, resulting in bias-cut gowns and trailer park vests. Owens playfully describes his darkly chic clothes as 'glunge' – a mix of glamour and grunge. Rather than show on a catwalk, he instead travelled the world throughout the '90s presenting his clothes to fashion buyers and developing an impressive client list that includes Madonna and Courtney Love. His reputation continued to grow by word of mouth and in 2002, American Vogue offered to sponsor his autumn/winter collection, his first on a runway. In the same year, Owens won the Perry Ellis Emerging Talent Award from the Council of Fashion Designers of America (CFDA). Moving to Paris in 2003 after scoring an artistic director contract with fur house Revillon, Owens – and his dark designs – have now found a home in his adopted city. LAUREN COCHRANE

"I'd describe my work as Frankenstein and Garbo, falling in love in a leather bar"

PORTRAIT BY TERRY JONES

RICK OWENS

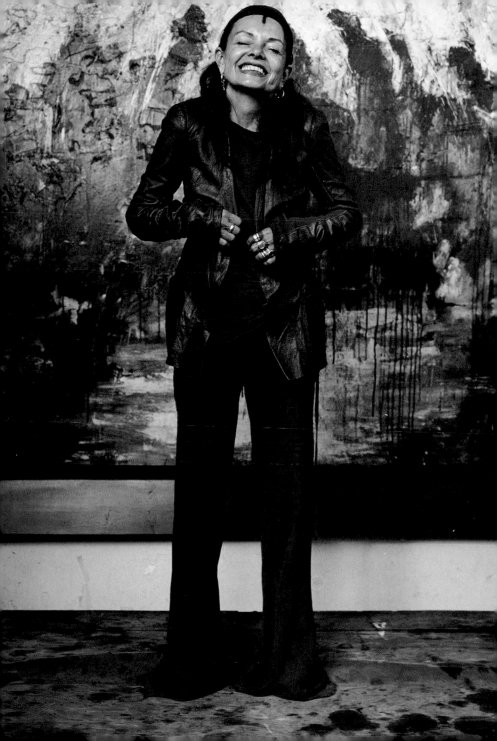

PHOTOGRAPHY BY RICHARD BURBRIDGE, STYLING BY EDWARD ENNINFUL. MARCH 2001. MODEL: STELLA TENNANT

In 1971 Miuccia Prada entered the family business. Twenty years later, the highly traditional leather goods company had changed beyond all recognition. The innovation of something as simple as a nylon bag meant there was no looking back: Prada was on the way to redefining luxury, subtlety and desirability in fashion. Prada the company – led by the designer and her husband, Patrizio Bertelli, who started work with Prada in 1977 and is now CEO of the Prada Group – seem to have an uncanny ability to capture the cultural climate in fashion. This sensitivity has been unashamedly teamed with commercial savvy, which has made the brand's influence over the past decade vast and its growth enormous. From bags and shoes to the first womenswear collection (1988), the Miu Miu line for the younger customer (1993), menswear (1994), Prada Sport (1997) and Prada Beauty (2000), all are directly overseen by Miuccia Prada herself. Yet, unlike many other Leviathan brands, there is something both unconventional and idiosyncratic in Miuccia Prada's aesthetic. Much of this may be down to her contradictory character. Born in Milan in 1950, Miuccia Prada studied political science at the city's university and was a member of Italy's Communist Party, yet is said to have worn Yves Saint Laurent on the barricades. The designer, who has made the Wall Street Journal's '30 Most Powerful Women In Europe' list, also spent a period studying to be a mime artist. These dualities have led to her expert ability in balancing the contrary forces of art and commerce within the superbrand, sometimes quite literally: Prada has its own art foundation and has collaborated with the architect Rem Koolhaas on stores in New York (2001) and Los Angeles (2004). From the late '90s, the Prada Group embarked upon a policy of rapid expansion, purchasing brands including Azzedine Alaïa, Helmut Lang and Church & Co.

JO-ANN FURNISS

"When people think of fashion, they always prefer to see the crazy side, the clichéd side of it. But I think that's wrong. Fashion is an important part of a woman's life"

MIUCCIA PRADA / PORTRAIT BY MARC QUINN

PRADA

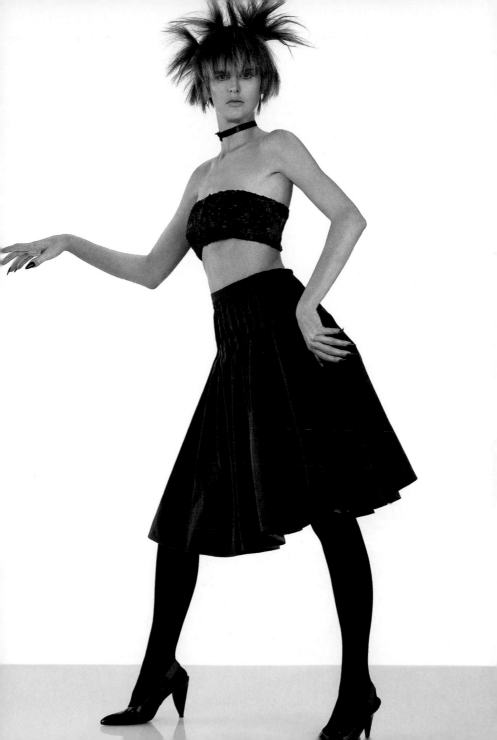

PHOTOGRAPHY BY HIROSHI KUTOMI, STYLING BY RACHAEL ZILLI. OCTOBER 2002

'Destroy, Disorientate, Disorder' and Debenhams, the British department store: John Richmond is equal parts raring-to-rock and ready-to-wear. The music-loving Mancunian has a singular talent for reconciling anarchic punk aesthetics with elegant tailoring. Born in 1961, Richmond graduated from Kingston Polytechnic in 1982 and worked as a freelance designer for Emporio Armani, Fiorucci and Joseph Tricot before forming his first label, Richmond-Cornejo, a collaboration with designer Maria Cornejo, in 1984. In 1987 he struck out on his own. During his career Richmond has dressed pop icons such as Bryan Adams, David Bowie, Madonna and Mick Jagger; George Michael wore Richmond's Destroy jacket in the video for 'Faith'. John Richmond designs are synonymous with the spirit of rock and the smell of leather. Today, his label comprises three clothing lines: John Richmond, Richmond X, and Richmond Denim, with eyewear and underwear collections also recently launched. A business partnership with Saverio Moschillo has provided Richmond with a worldwide network of showrooms, from Naples, Rome and Paris to Munich, Düsseldorf and New York. They house his leather biker jackets, oil-printed T-shirts, acid-orange pleated skirts and long-line sweaters. Richmond's newest flagship store in London's Conduit Street joins two Italian shops in Milan and Bari. Then there's the Designers At Debenhams collection, the John Richmond Smart Roadster car — needless to say, a John Richmond fragrance and a childrenswear collection are also both in the pipeline. NANCY WATERS

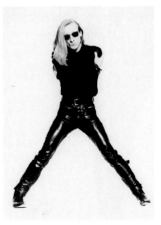

"I never get bored! I often think how lucky I am just for being able to do all the things I wanted to do"

PORTRAIT COURTESY OF JOHN RICHMOND

JOHN RICHMOND

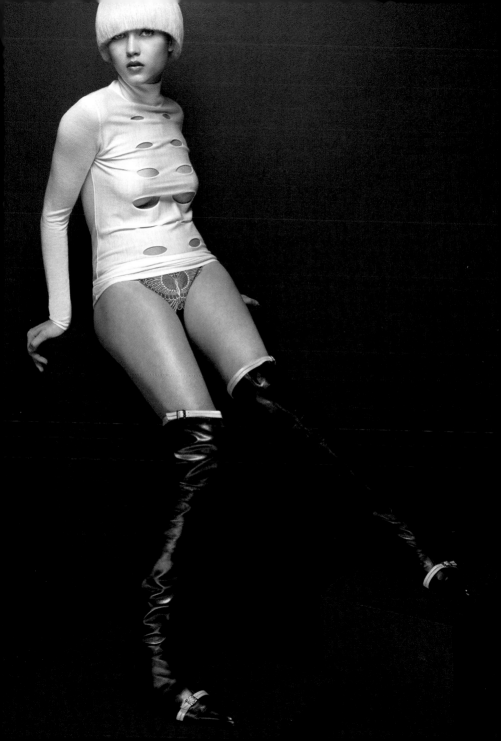

PHOTOGRAPHY COURTESY OF NARCISO RODRIGUEZ. SPRING/SUMMER 2002

Narciso Rodriguez designs clothes that are sliced, cut and put together with apparently effortless finesse. They are fluid and simple, architectural and modern, easy to wear but not casual, dressed-up but not too over-the-top. Rodriguez has an impeccable list of credentials. He graduated from Parsons School of Design in 1982, and after a brief period freelancing, joined Donna Karan at Anne Klein in 1985. He worked there for six years before moving to Calvin Klein as womenswear designer. In 1995 he relocated to Paris where he stayed for two years with Cerruti, first as women's and men's design director, and then as creative director for the entire womenswear division. Never one to slow down the pace, in 1997 Rodriguez not only showed his debut signature line in Milan, but also became the womenswear design director at leather goods brand Loewe, a position he retained until 2001. In 2003 he received the CFDA's womenswear Designer of the Year Award and in 2004 was the recipient of the Hispanic Heritage 'Vision Award'. Since 2001 he has concentrated on his eponymous line, which is produced and distributed by Aeffe SpA and shown at New York Fashion Week. Rodriguez's Latin roots (he was born in 1961 in New Jersey to Cuban-American parents) inspire the slick, glamorous side of his work while his experience in Europe has honed his fashion craftsmanship and tailoring expertise. This perfectly stylish balance has seduced some of the world's loveliest ladies, including Salma Hayek, Julianna Margulies and the late Carolyn Bessette, who married John F. Kennedy Jr. in a Rodriguez creation. His autumn/winter 2005 collection was, as ever, perfect and precise fashion design, aimed at uptown sophisticates: black dresses were cut to reveal a sliver of décolletage and mannish suits had a lean, body-conscious line. TERRY NEWMAN

"As hard and painful as designing can be, it is the thing I have always been most passionate about"

PORTRAIT BY TONY TORRES

NARCISO RODRIGUEZ

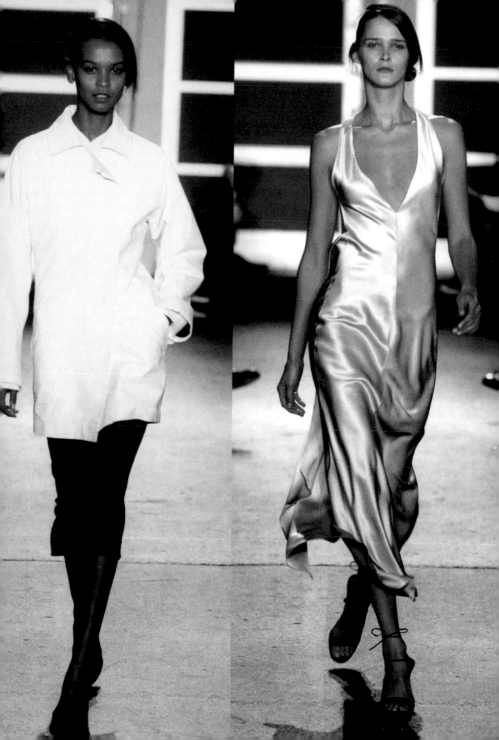

PHOTOGRAPHY BY ROBERT WYATT, STYLING BY LUCY EWING. AUGUST 2001

Known for sculpting fabric around the human form with his complex constructions, Gilles Rosier is that rare thing in modern Parisian fashion – a native Frenchman. Born in Paris in 1961 to a French father and German mother, Rosier had an itinerant childhood, travelling through Algiers, Port-Gentil and Kinshasa with his family. On his return to Paris, Rosier had acquired both a talent for drawing and the ability to adapt to changing circumstances, skills that have served him well over his career. He studied at the Ecole de la Chambre Syndicale de la Couture, graduating in 1982. Apprenticeships right at the heart of haute couture – with Pierre Balmain and Christian Dior – were followed by a position at Guy Paulin. In 1987, he became assistant to Jean Paul Gaultier and five years later finally went solo, with a single season designing menswear for print house Léonard. In the same year, Rosier launched his own label entitled GR816, while simultaneously taking up the role of creative director at Lacoste, where he remained for seven years. But it was at Kenzo that Rosier made perhaps his greatest impact so far when he was chosen by Kenzo Takada himself to succeed him as artistic director at the LVMH-owned label. From 1998 to 2003, the younger designer managed to evolve the house's exuberant history with the introduction of a sophisticated new image that harnessed his own fascination with colour and contrast. In February 2004, yet another new location beckoned: Milan, where Rosier re-launched his eponymous label with romantic black tailoring for women, produced by Italian group Miroglio. For spring/summer 2005, he extended his repertoire to include menswear. Gilles Rosier also occasionally finds time to act in theatrical productions of plays by Shakespeare and Chekhov.

SUSIE RUSHTON

"I would love to be designing clothes that reveal personality"

PORTRAIT BY DUC LIAO

GILLES ROSIER

PHOTOGRAPHY BY MATT JONES, STYLING BY DIANA OBERLANDER. AUGUST 2002. MODEL: AIMÉE MULLINS

The so-called 'Queen of Knits', Sonia Rykiel is synonymous with Paris. Born in the city in 1930, she went on to encapsulate Parisian style with her chic fashion line. As an expectant mother, she had discovered that there were no sweaters available that were soft and flexible enough for her to wear through her pregnancy, so, in 1962, she created her own line of knitwear. This was so successful that she opened her first boutique in that momentous Parisian year, 1968. And, in their own way, Rykiel's designs were revolutionary. Her flattering knits – often in what was to become her trademark stripes – symbolised liberation for women's bodies from the stiff silhouette of the previous decade. She also increased the sex appeal of knits: freed from linings and hems, her dresses and sweaters were like second skins for the women who wore them. Rykiel has continued to build her very own French Empire since the '70s. She recognised the wisdom of establishing a beauty line early on, launching a perfume in 1978 and cosmetics in 1987. Completely independent, Rykiel's business is very much a family affair. Husband Simon Bernstein is her business partner and daughter Nathalie Rykiel has been involved in the company since 1975. With such support, Sonia has the freedom to do other things. Today, Madame Rykiel is something of a French institution. She has written novels, decorated hotels, sung a duet with Malcolm McLaren and even had a rose named after her. And the accolades keep on coming. Rykiel has been awarded an Oscar by Fashion Group International and in December 2001, the French government named her Commandeur de l'Ordre National du Mérite. Now in her seventies, the grande dame of French fashion shows no signs of giving up. She has an army of sweater-loving women depending on her, after all.

LAUREN COCHRANE

"I hope that my creations can give a little bit of joy"

PORTRAIT BY SARAH MOON

SONIA RYKIEL

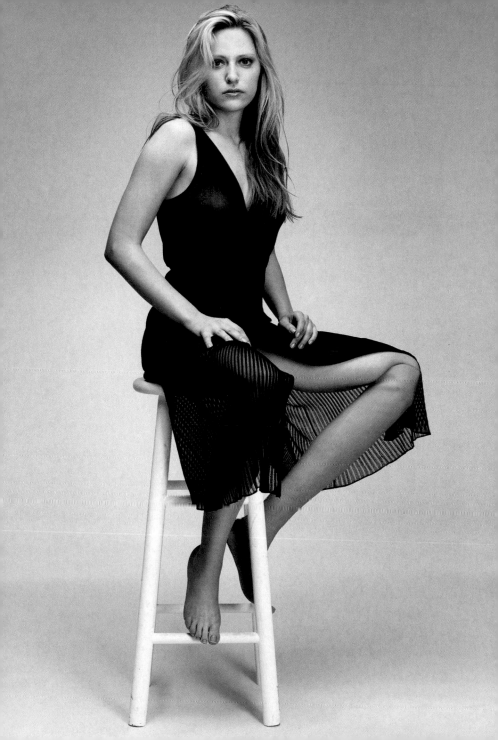

PHOTOGRAPHY BY JASON EVANS, STYLING BY SIMON FOXTON. MODEL: HANNAH. OCTOBER 2004

Jil Sander is a name synonymous with a particularly pure and understated type of fashion. The German-born designer, who launched her first women's collection back in 1973, is closely associated with '90s minimalism, yet her philosophy of fashion is far from simplistic. On opening her first shop, in Hamburg, at the age of 24, Sander used fabrics traditionally associated with menswear for her women's clothing, demonstrating an androgynous aesthetic that would endure throughout her career; a long-time signature design is the perfectly-cut white shirt, as is the trouser suit. Jil Sander is also renowned for the development and use of high-tech, yet extremely luxurious, fabrics. The rigorously-considered proportions of her clothing gained Sander a faithful following among sophisticated working women who valued graceful, clean lines over obvious sex appeal or froth. In 1979 Jil Sander Cosmetics was launched, followed by a leather collection in 1984. The company became a publicly-traded concern in 1989 and a period of rapid expansion followed, with flagship stores opening in Paris, Milan and New York in the early '90s. In 1997, the first menswear collection was shown in Milan. The serenity of Jil Sander clothing is in marked contrast to the corporate history of the company. In 1999 the Prada Group acquired a majority holding in Jil Sander AG and the following year Sander exited her own company; in November 2000 Milan Vukmirovic was named creative director of both men's and women's collections. However, to the surprise of industry observers, in 2003 Sander returned to the company she founded and for three seasons wowed press and customers with a subtly feminine aesthetic. But in November 2004 she split from her brand and the Prada Group once again. A team of studio designers, many of whom had trained directly under Sander, took over the reigns at the house for a period, until it was announced in May 2005 that Raf Simons was to be the new artistic director of the brand.

SUSIE RUSHTON

"We need to learn to decipher and translate the symbols, signals and hieroglyphs that tell us about the future. Even if only to find them in ourselves"

PORTRAIT BY GIOVANNI GIANNONI

JIL SANDER

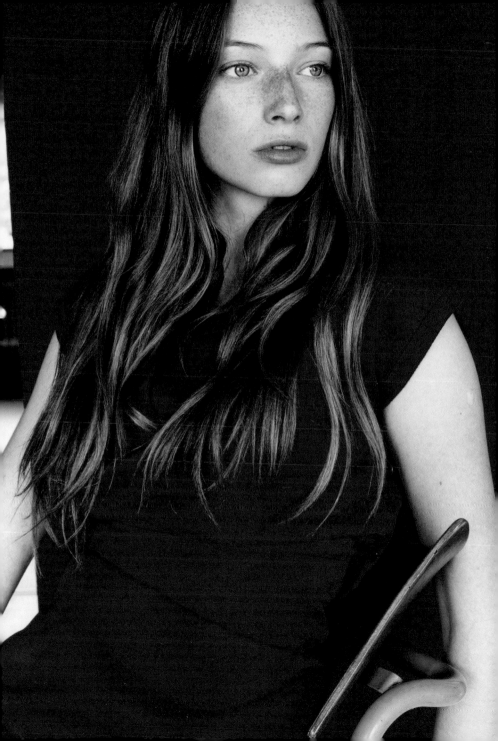

PHOTOGRAPHY BY KAYT JONES, STYLING BY PATTI WILSON. FEBRUARY 2003

Jeremy Scott's story is the stuff of fairy-tales and syndicated game shows. Born in 1974 and raised in Kansas City, Missouri, Scott was the boy who read Italian Vogue between classes and wrote about fashion in French essays. After graduating from New York's Pratt Institute, the 21-year-old made a pilgrimage to Paris where his collection, made out of paper hospital gowns and inspired by the body-modifying artist Orlan, went down in fashion folklore. His first formal runway presentation in October 1997, 'Rich White Women', presenting asymmetrically cut trousers and multifunctional T-shirts, established Scott as a substantial Parisian presence. But controversy clings to the designer like a Pierre Cardin teddy bear brooch. Later collections, such as March 1998's infamous 'Contrapied' show, have met with a mixture of incredulity and derision, all the while establishing key details of the Scott aesthetic: attention to volume, obsession with logos (including best-selling back-to-front Paris print), a hard-edged Mugler-esque glamour and a wicked way with fur. In autumn 2001, Scott relocated to Los Angeles, a city that has wel-comed his über-trash style with open arms to such an extent that in January 2002 he achieved one of his long-term ambitions, appearing as a celebrity contestant on 'Wheel of Fortune'. Scott continues to show in New York and LA, with recent projects including a short feature film starring celebrity clients and friends such as Asia Argento and Lisa Marie. As Scott himself might say, vive l'avant-garde! GLENN WALDRON

"I love creating and I hate the empty feeling when it's done"

PORTRAIT BY ALEX HOERNER

JEREMY SCOTT

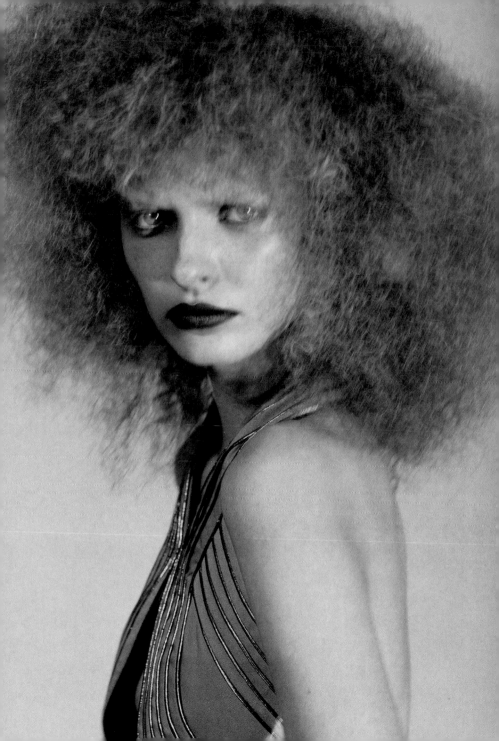

PHOTOGRAPHY BY DAVID ARMSTRONG, STYLING BY PANOS YIAPANIS. FEBRUARY 2005. MODEL: JERMAINE JOY

Although he is now one of the indisputable kings of menswear, Raf Simons (born 1968) never took a single fashion course. Instead, he studied industrial design in Genk, Belgium, close to his hometown Neerpelt. Nevertheless he took an internship at the Walter Van Beirendonck Antwerp office while still at school, citing fashion as a major point of interest. Afterwards Simons started working as a furniture designer, but gradually grew unhappy with this direction. In 1995, after moving to Antwerp and meeting up with Linda Loppa, head of the fashion department at the city's Royal Academy, he decided to switch career. Obsessed both by traditional, formal menswear and the rebellious dress codes of present and past youth cultures, Simons distilled a groundbreaking new style from these inspirations. From his first collection for autumn/winter 1995 on, he drew a tight, linear silhouette executed in classical materials that encapsulated references like English schoolboys, gothic music, punk, Kraftwerk and Bauhaus architecture. Despite international acclaim, Raf Simons surprisingly shut down his company after presenting his autumn/winter 1999 collection, in order to take a sabbatical and re-arrange the internal structure of his business. After sealing a close co-operation with Belgian manufacturer CIG, Simons returned for autumn/winter 2000 with a new, multi-layered and radical look, worn as ever by non-professional models scouted on the streets of Antwerp. These teenage boys were the subject of a collaboration with David Sims, resulting in photographs compiled in a book ('Isolated Heroes', 1999). Raf Simons designed the Ruffo Research men's collections for two seasons in 1999. Since October 2000, he has taught fashion at the University of Applied Arts in Vienna, and in February 2001 he guest edited an issue of i-D. In 2003 Simons curated two exhibitions ('The Fourth Sex' at Pitti Immagine, Florence, and 'Guided By Heroes' in Hasselt, Belgium) and collaborated with Peter Saville on his autumn/winter 2003 collection, 'Closer'. In May 2005 it was announced that Simons would take over as creative director at Jil Sander.

PETER DE POTTER

"The collections have been part of the process of growing up"

PORTRAIT BY FABRIZIO FERRI

RAF SIMONS

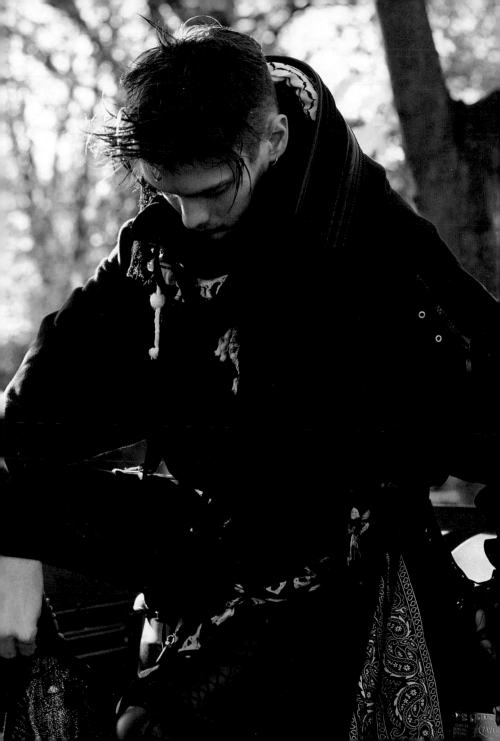

PHOTOGRAPHY BY CHRISTOPHE RIHET, STYLING BY HAVANA LAFFITTE. NOVEMBER 2002

Martine Sitbon is a designer whose eye roves the globe for inspiration, referencing and subverting an eclectic mix of cultures while never exploiting her exotic upbringing. The child of an Italian mother and French father, Sitbon was born in Casablanca in 1951. At the age of ten she moved to Paris, where she experienced first-hand the social transformations the city went through in the late '60s. She studied at the famed Studio Berçot, graduating in 1974 before going travelling – adding a multicultural edge and love of lush textiles to the technical fashion skills she had acquired. After spending seven years rummaging through Hong Kong, Mexico, India, New York and Milan, she later fed this blend of the exotic and urban into her designs. In 1985 Sitbon launched her own label and presented her first show in Paris with a collection that famously gathered together monks' hoods, pastel colours, bloomers and a Velvet Underground soundtrack. Black may be key to the palette of the artistic intelligentsia, but Sitbon has enticed them with combinations of sober shades that threaten to clash head-on, but swerve just at the last minute. Her coolly dishevelled clothing often uses elements of leather and masculine tailoring to juxtapose the flea-market femininity of velvets, silks and satins. These contrasting combinations saw her recruited by Chloé in 1988 to design the label's womenswear line, a collaboration that lasted for nine seasons. In 1996 Sitbon opened her first boutique in Paris, and in 1999 she launched a menswear collection into which she introduced her unapologetically androgynous aesthetic. From 2001 to 2002 Sitbon was head designer for womenswear at Byblos. Now concentrating on her own-label menswear and womenswear, Sitbon remains the choice for those who love fashion's more eclectic side.

LIZ HANCOCK

"The perpetual 'restart' of fashion is very interesting and this permanent evolution is what pushes me to stay in this profession"

PORTRAIT COURTESY OF MARTINE SITBON

MARTINE SITBON

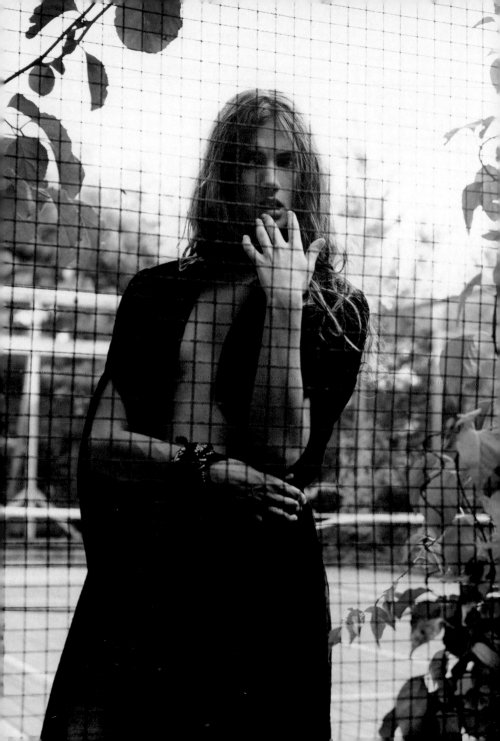

Luxuriously tailored designs with a subtle, subversive twist; a coherent blending of couture tradition and unflinching modernism; a lean, sexy, often androgynous silhouette: these are the signatures of designer Hedi Slimane. Born in Paris in 1968, Slimane began making clothes as a teenager. Perhaps surprising given his focus on precision cut and tailoring, Slimane received no formal training, instead choosing to study History of Art at Ecole du Louvre. He joined French designer José Lévy in 1992, becoming assistant to Jean-Jacques Picart, and working in various behind-the-scene roles for the next five years. In July 1997, the relatively unknown Slimane was appointed Artistic Director of Yves Saint Laurent Rive Gauche Homme. Over the next three years at YSL, he would reinvigorate their ready-to-wear menswear line, combining a respectful appreciation of Yves Saint Laurent history with a sharp, often erotic take on modern glamour. Following the Gucci Group's purchase of Yves Saint Laurent, Slimane left Rive Gauche Homme in March 2000; his swan song, the 'Black Tie' collection for autumn/winter 2000, would stand as a touchstone for his uncompromising vision of male elegance. After a two season hiatus, Slimane was appointed Creative Director for Menswear at Christian Dior. His first collection for the French house, reworking his razor slim silhouette with brutally perforated leather tuxedos, met with universal acclaim. In February 2002, the first Dior Homme boutique opened in Milan and in April, he was named Designer of the Year by the CFDA. Concurrent with his design work, Slimane has also presented an installation at the 62nd Pitti Immagine Uomo Fair in Florence, accompanied by a book of his photography, 'Transmission'. He continues to play a central role in redefining the shape – and significance – of menswear within contemporary fashion. "I'd like men to think about evolving into something more sophisticated, more seductive," he has declared. "To explore the possibility of an entirely new kind of masculinity."

"I'd like men to think about evolving into something more sophisticated, more seductive. To explore the possibility of an entirely new kind of masculinity"

PORTRAIT BY WOLFGANG TILLMANS

HEDI SLIMANE

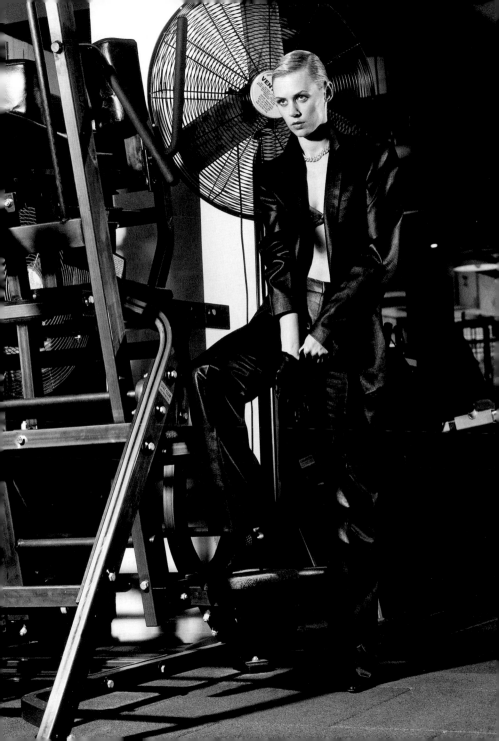

PHOTOGRAPHY BY KENT BAKER, STYLING BY MARK ANTHONY. SEPTEMBER 2000

A serious accident while riding his bike put paid to Paul Smith's dream of becoming a professional racing cyclist. However, this mishap propelled him to pursue a career involving his other passion: fashion. In 1970, Smith (born Nottingham, 1946) opened a store in his native city, selling his own early designs that reflected the types of clothing he loved but was unable to buy anywhere else. Studying fashion design at evening classes, and working closely with his wife, Pauline Denyer, a graduate of the Royal College of Art, by 1976 he was showing a full range of menswear in Paris. Carving out a distinctive look that combined the best of traditional English attire often with unusual or witty prints, Smith blazed a trail throughout the late '70s. His progress continued into the '80s – when he put boxer shorts back on the fashion map – and beyond, with stores opened in New York (1987), and Paris (1993). The designer now has a staggering 200 shops in Japan, and also offers a range of womenswear (launched in 1994) and clothing for kids, in addition to accessories, books, jewellery, fragrances, pens, rugs and china. In 2001 Smith was knighted, and despite the success and breadth of his company – wholesaling to thirty-five countries around the globe – his hands-on involvement remains integral to its success. Commercial accomplishments aside, Smith's aesthetic has retained its idiosyncrasies. His autumn/winter 2005 womenswear collection, with its tartan tailoring and trilbies, was a sideways glance at the '60s; for his menswear, in the same season, Smith gave a lesson in clash and contrast, putting python trousers with checked jackets and floral shirts.

JAMES ANDERSON

"The thing I'm most interested in is continuity. I've always worked hard at not being today's flavour"

PORTRAIT BY IDESU OHAYO

PAUL SMITH

PHOTOGRAPHY BY TAKAY, STYLING BY MARK ANTHONY. DECEMBER 2001/JANUARY 2002

Twenty-five years is a pretty long time in anyone's books. Most marriages fail at seven, cars conk out at ten, so to notch up a quarter-century anniversary is a feat in itself. Launched in Laguna Beach, California, back in the day, a certain Shawn Stüssy was so captivated by the lifestyle and apparel born on the beach that he decided to adopt the laconic uniform as his own, and morph his name – or, more accurately, his distinct signature – into one of the world's most recognised brands. Like a match to an unlit firecracker, things went fizzing sky-high in an instant, with like-minded surf rats empathising instantly with the graphic-based designs on boards, tees and sweats, all born of integrity and an unforced insider's knowledge. An instant cult hit, come the mid-'80s the brand effortlessly rode a tidal wave all the way to New York and London, and the coolest kids in the hottest clubs donned the label as an instant drag on the cigarette of cool. Limiting the global availability ensured the longevity of the brand, and come the '90s, Stüssy decided to fully realise their potential and opened flagship stores in London and New York. A stickler for perfection, Shawn ensured every product was executed to the highest standard, and kept local interest fixed up thanks to the ongoing collaborative site-specific projects with local designers and artists. Like a grand king happy to look down on his kingdom and reap the rewards he had sown, he decided to pass his heavy-weight inscribed mantle onto a new team, and appointed Nicholas Bower and Paul Mittleman to lead and direct the creative direction for Stüssy. As integrated into popular culture as 'The Simpsons' or hip hop, Stüssy is populist, Stüssy is street culture. Long may it reign supreme. BEN REARDON

"We describe our work as 'remixing'"

SHAWN STÜSSY / PORTRAIT COURTESY OF PAUL MITTLEMAN

STÜSSY

PHOTOGRAPHY BY SEAN CUNNINGHAM. SPRING/SUMMER 2003

Anna Sui's singularity lies in her ability to weave her own passions into her work. Her creations are intricate pastiches of vintage eras and knowing nods to music and popular culture – from '60s Portobello to downtown rockers and B-Boys. Her love of fashion began early. Growing up in a sleepy suburb of Detroit, Sui (born 1955) spent her days styling her dolls and collating her 'genius files', a source book of magazine clippings that she continues to reference today. In 1972, she began studying at Parsons School of Design in New York, where she became a regular on the underground punk scene and where she met photographer Steven Meisel, a long-time friend and collaborator. Sui spent the remainder of the '70s designing for a string of sportswear companies. Then, in 1980, she presented a six-piece collection at the Boutique Show, receiving an immediate order from Macy's. Sui made her runway debut proper in 1991; the collection was a critically-acclaimed homage to her heroine, Coco Chanel. And by the early '90s, her self-consciously maximalist look was helping to pave the way for designers like Marc Jacobs, sparking a revival in the New York fashion scene. In 1993, she won the CFDA Perry Ellis Award for New Fashion Talent. Sui encapsulated the grunge spirit of the times, with Smashing Pumpkins guitarist James Iha – a close friend – appearing in her winter 1995 'California Dreaming' show, and Courtney Love famously adopting Sui's classic baby-doll dresses. Nowadays, Sui has stores in New York, LA, Tokyo and Osaka, and has added denim, sportswear, shoes and accessories to her brand. Her kitsch cosmetics and best-selling fragrances, with distinctive rose-embossed packaging, have all helped to establish her as an important designer and shrewd business woman with an eccentric spirit and limitless sense of fun. AIMEE FARRELL

"People who go to my fashion shows kinda go to a rock concert"

PORTRAIT BY GREG KADEL

ANNA SUI

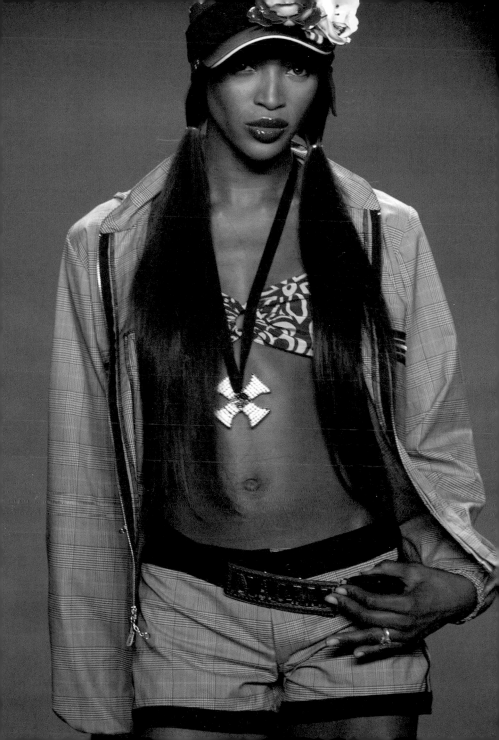

PHOTOGRAPHY BY HIROSHI KUTOMI, STYLING BY YOSHIYUKI SHIMAZU. APRIL 2000

Naoki Takizawa (born Tokyo, 1960) is not an instantly recognisable name in the world of fashion. This is not because he is on the fringes or his designs unfamiliar. In fact, quite the opposite is true. Designer of both Issey Miyake menswear (since 1993) and womenswear (since 1999), Takizawa is one of the most important Japanese designers working today. Graduating from Kuwasawa Design Institute in 1982, he immediately joined the Miyake Design Studio. Initially he worked as designer of the newly formed Plantation line, a range that used natural fibres, focusing particularly on loose comfort and affordability. The Miyake Design Studio is renowned as a workplace for developing talent, but it also serves as a research base and, over the last ten years, Takizawa has been instrumental in the development of fabric and manufacturing techniques through new technologies. It is this, combined with the social function of clothing present in Miyake's early work, which currently defines his collections. His catwalk shows, both menswear and womenswear, are often theatrical affairs that attempt to explore the relationship between civilisation and clothes. Like many of his Japanese counterparts, Takizawa shies away from rigid tailoring and brings a gentle fluidity to both his men's and womenswear, conscious of the space between garment and wearer, something Miyake himself explored extensively. Aside from mixing colour and tone in his work, Takizawa has previously presented pieces influenced by sportswear and workwear. Through the appointment of Takizawa, Issey Miyake (who now devotes his time to the A-POC collection) has reinforced the Japanese desire for evolution and ensured that an inquisitive mind is still in charge of his eponymous label.

"I want to reach and touch people through my own expression"

PORTRAIT COURTESY OF NAOKI TAKIZAWA

NAOKI TAKIZAWA

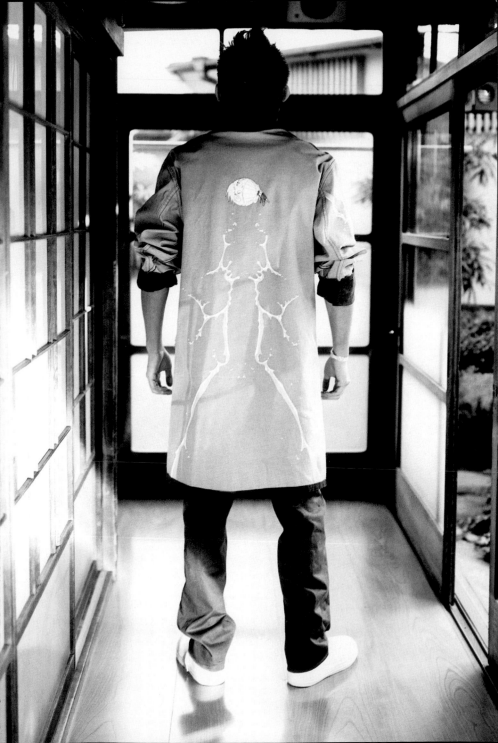

PHOTOGRAPHY BY KEVIN DAVIES. SPRING/SUMMER 2000

Philip Treacy's feathered, fur-trimmed or velvety creations have little in common with conventional headwear. In fact, Treacy's glamorous and fantastical hat designs have completely re-defined modern millinery. Fashion leaders such as Franca Sozzani, Amanda Harlech and Isabella Blow (the latter has worn Treacy hats from the beginning of his career) covet his work. Oversized orchids, fans of pheasant feathers, model ships and Andy Warhol-style motifs have all decorated his deftly-sculpted hats. Treacy was born in Ahascragh, western Ireland, in 1967. By the age of five, he was making clothes for his sister's dolls. His fashion education began in 1985 at Dublin's National College of Art and Design where he started to make hats as a hobby. Following a work experience placement at Stephen Jones, Treacy began an MA womenswear course at London's Royal College of Art in 1988. However, he decided to ditch clothing design and take a place on the college's first-ever millinery course. In 1991, at the age of 23, he started making hats for Chanel and, in the same year, won the Accessory Designer prize at the British Fashion Awards for the first time; to date he has won three such accolades. In 1993 he staged his debut fashion show during London Fashion Week, where Naomi Campbell and Christy Turlington walked his catwalk in return for free hats. In 1994 he opened his first boutique, in London's Belgravia, and in 2000 Treacy became the first accessories designer to be invited by the Chambre Syndicale de la Haute Couture to show his work during Paris couture week. Treacy collaborates with some of the world's finest artists and designers, including Alexander McQueen and Vanessa Beecroft, and his work is displayed in museums such as the V&A and the Design Museum in London and the Irish Museum of Modern Art. In 2004 he won the Chinese International Designer of the Year Award; 2005 sees the completion of his first interior design project, at The G, a five-star hotel in Galway, Ireland. TERRY NEWMAN

"Making a hat is like throwing a party!"

PORTRAIT BY KEVIN DAVIES

PHILIP TREACY

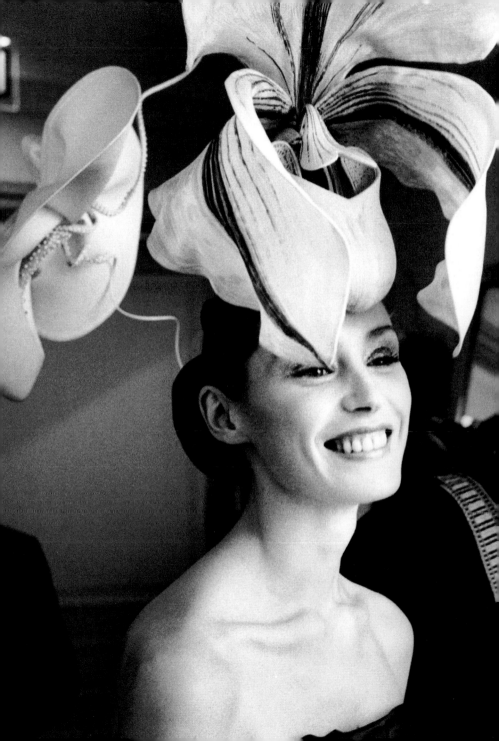

PHOTOGRAPHY BY HIROSHI KUTOMI, STYLING BY YOSHIYUKI SHIMAZU. AUGUST 2002

Founded by Japanese designer Jun Takahashi in 1994, the Undercover label now includes some seriously discerning types among its fan base, not least Rei Kawakubo, who in 2004 had the 34-year-old design a selection of blouses to sell in the Comme des Garçons store in Tokyo. Born in Kiryu, in 1969, and a graduate of the Bunka Academy, it was while studying at college that Takahashi began making clothes to wear himself, frustrated at not being able to find anything he liked in shops. His confidence and individuality sets him apart from many young Japanese designers, who are happy to rely on easily digestible, graphic-led T-shirts and slogans. Takahashi's approach is more complex and distinctive, and has been variously described as 'thrift-shop chic' or 'subversive couture'. Considering his belief that life is as much about pain as it is about beauty, it is not surprising that the resulting Undercover aesthetic makes for an anarchic collision of the violent (slashed, ripped and re-stitched fabrics) and the poetic (chiffon, lace and faded floral prints). Further clues to the designer's mindset are found in his fondness for defiant English punk bands – while still a student, he was a member of the Tokyo Sex Pistols, a tribute act, and is often spotted sporting a Crass T-shirt. Having won the Grand Prize in the prestigious Mainichi Fashion Grand Prize in 2001 and made his Paris catwalk debut with his spring/summer 2003 collection, Takahashi today continues to up the ante. Undercover is now split into five lines – Undercover, Undercoverism, Undakovit, Undakovrist and Undakovr, all of which are sold through a flagship store in Tokyo's fashionable Omotesando district. Further Undercover stores have opened in Paris and Milan, while global stockists continue to grow in tandem with appreciative converts to the label. JAMES ANDERSON

"I cannot deny the difficulty involved in creating designs. But I think I continue creating them because I enjoy it"

JUN TAKAHASHI / PORTRAIT COURTESY OF JUN TAKAHASHI

UNDERCOVER

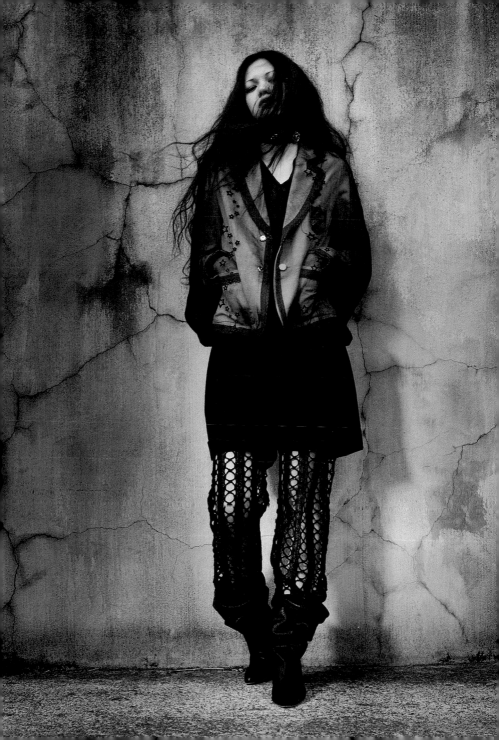

Valentino Garavani – who, like all megastars, is known simply by his first name – is Italy's greatest couturier and one of the most respected designers showing in Paris. While wannabe glamour girls lust after his V-logo belts and bejewelled sandals, to his loyal following of moneyed couture clients Valentino is synonymous with showstopping evening dresses, which are immaculately cut in lean, feminine lines with dramatic flourishes such as ruffles, romantic embroideries and judicious use of his favourite shade of bright red. Born in Voghera, south of Milan, in 1932, Valentino travelled to Paris at just 17 and, following studies at the Chambre Syndicale de la Mode, was apprenticed to Jean Dessès and Guy Laroche. In 1959 he returned to Italy to establish his own atelier on Via Condotti in central Rome. In 1962, he launched his first full collection, to universal acclaim, at the Palazzo Pitti in Florence, and by 1967 he had won the Neiman Marcus Award, the first of many accolades. Appearances on the covers of both Time and Life magazines followed, and in 1968 Valentino was chosen by Jackie Kennedy to design the dress for her wedding to Aristotle Onassis. At the end of the '60s, Valentino met Giancarlo Giametti, a former architecture student who would become the business brains behind the expanding fashion house and in 1970 ready-to-wear collections, for both men and women, were debuted. By 1998 the pair had decided to sell the house, to Italian conglomerate Holding di Partecipazioni Industriali, which in turn sold the brand to Marzotto, in 2002. In July 2005 Marzotto created Valentino Fashion Group, which operates as a separate, publicly-traded concern. Over the years the perfectly-groomed designer has dressed the most privileged women of the day, including Princess Margaret, Marella Agnelli and Begum Aga Khan. In 2002 his Hollywood credentials were re-affirmed when Julia Roberts wore an elegant black-and-white vintage Valentino dress to the Oscars. Valentino has been honoured by the governments of Italy, where he was awarded the Cavaliere di Gran Croce (1986) and France, which decorated him as a Chevalier de la Légion d'Honneur (2005). SUSIE RUSHTON

"I design for romantic people"

PORTRAIT BY FABRIZIO FERRI

VALENTINO

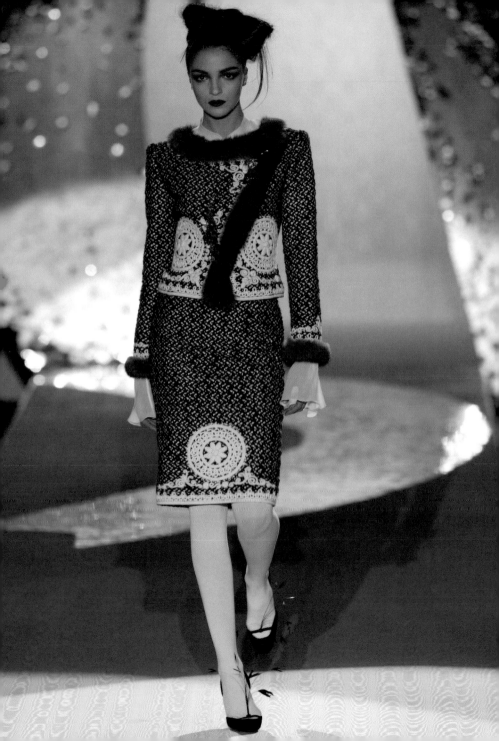

In March 2005 Giambattista Valli showed his first eponymous collection in Paris. His debut emphasised polished pieces such as curvy tuxedos or tiny cocktail frocks in scarlet chiffon or black tulle. The Italian designer (born in Rome, 1966) already had an impressive CV by that time however, with a role as artistic director of Emanuel Ungaro's ready-to-wear collections as his most high profile appointment to date. Valli, who grew up in Rome, cites quintessential glamorous movie icons such as Claudia Cardinale, Marilyn Monroe and Rita Hayworth as early influences. His formal studies focused more squarely on fashion from 1980 when he studied at Rome's School of Art, followed by fashion training at the European Design Institute (1986) and an Illustration degree at Central Saint Martins in London (1987). In 1988 Valli worked for seminal Roman designer Roberto Capucci, moving to Fendi as a senior designer of the Fendissime line in 1990; in 1995 he was appointed senior designer at Krizia. The following year, through a mutual friend, Valli met Emanuel Ungaro. The master couturier named Valli head designer of his ready-to-wear collections in 1997, eventually promoting him to the position of creative director of Ungaro ready-to-wear two years later. At Ungaro, Valli translated the established house codes of tumbling ruffles, tropical-flower colours and elegantly draped, ultra-feminine gowns for a younger generation of jet-setting glamour girls. Besides glitzier idols such as Halston and Marie-Hélène de Rothschild, Valli also cites Francis Bacon, Kurt Cobain and Nan Goldin as continual sources of inspiration. SUSIE RUSHTON

"I cannot live without design. I am design-addicted"

PORTRAIT BY KEVIN DAVIES

GIAMBATTISTA VALLI

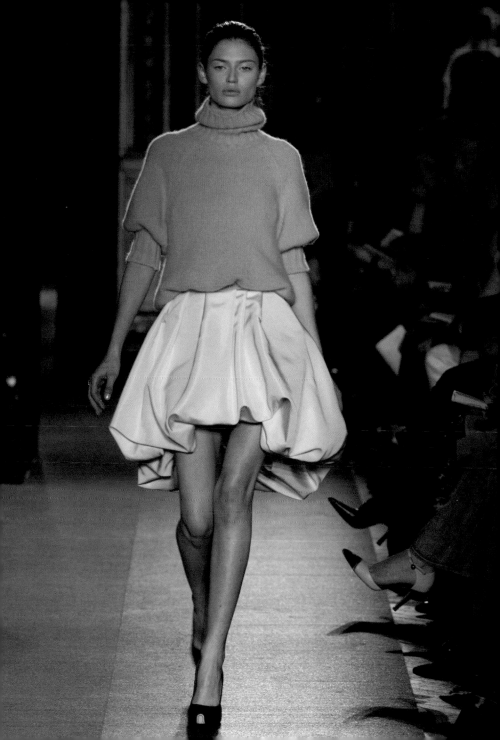

PHOTOGRAPHY BY ALASDAIR MCLELLAN, STYLING BY THOM MURPHY. OCTOBER 2000

If Walter Van Beirendonck were in a band, it would play a fusion of punk, folk, trash, pop, techno and chamber music. One of Belgium's most prolific fashion designers, Van Beirendonck places his sense of humour to the fore of his creations in an approach that humanises the sexuality which is often woven into his garments as patterns and graphics. Safe sex is a common thematic thread, as are literary, cinematic and folkloric references. Knitwear also plays a large part in Van Beirendonck's repertoire, but no prim twin sets or crewnecks for him – his jumpers are likely to come with matching balaclavas bearing garish cartoon faces, bold messages, or sexual motifs. Born in Belgium in 1957, Van Beirendonck studied at Antwerp's Royal Academy. Part of the legendary Antwerp Six who brought Belgian fashion to greater public consciousness with their 1987 London show, Van Beirendonck – along with Dirk Van Saene, Dries Van Noten, Dirk Bikkembergs, Marina Yee and Ann Demeulemeester – was responsible for moving fashion towards a new rationale. From 1993 to 1999 he created the cyberpunk label that was W< (Wild and Lethal Trash), after which he re-launched his eponymous line, Walter Van Beirendonck. A second line, Aestheticterrorists, was founded in 1999. He has taught at the Royal Academy since 1985 and has designed costumes for stage, film and for bands such as U2 and Avalanches. He has curated exhibitions in the world's top galleries and has also illustrated books, created his own comic and won numerous awards. In March 1998 the book 'Mutilate' was dedicated to Van Beirendonck's first 10 years in fashion, and in September 1998 he opened his own store, Walter, in Antwerp. Van Beirendonck could be described at the industry's blue-sky thinker, for both his visionary perspective, and his constantly optimistic outlook. LIZ HANCOCK

"My goal is to change the boundaries of fashion"

PORTRAIT BY TERRY JONES

WALTER VAN BEIRENDONCK

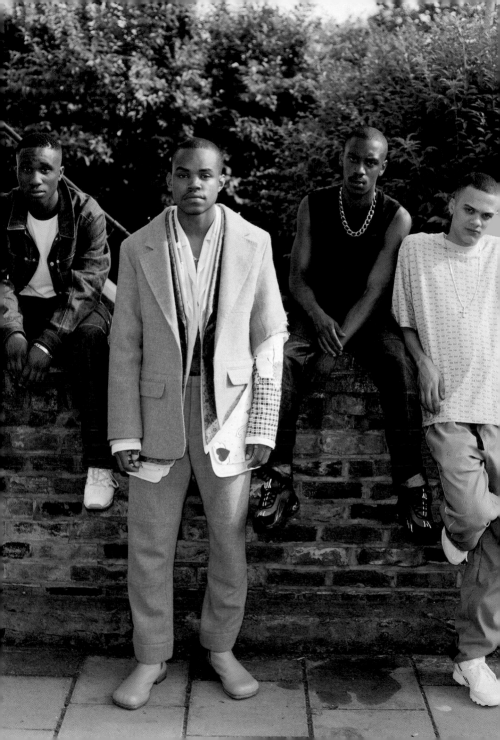

PHOTOGRAPHY BY PAUL WETHERELL, STYLING BY SORAYA DAYANI. MARCH 2002

Dries Van Noten's culturally diverse style has made him one of the most successful of the 'Antwerp Six' designers who arrived at the London collections back in March 1986. His signature full skirts, soft jackets and scarves are embroidered or beaded using the traditional folkloric techniques of India, Morocco or Eastern Europe – whichever far-flung culture has caught his attention that season. Born in Antwerp, Belgium, in 1958 to a family of fashion retailers and tailors, Van Noten enrolled at the city's Royal Academy in 1975; to support his studies, he worked both as a freelance designer for various commercial fashion companies and as a buyer for his father's boutiques. Following the legendary group show in London, Van Noten sold a small selection of men's shirts to Barneys in New York and Whistles in London; these stores then requested that he make smaller sizes, for women. In the same year, Van Noten opened his own tiny shop in Antwerp, subsequently replaced by the larger Het Modepaleis in 1989. In 1991, he showed his menswear collection in Paris for the first time; a womenswear line followed in 1993. Van Noten is perhaps the most accessible of the Belgian designers, but his theory of fashion is far from conventional. He prefers to design collections 'item by item', offering his clients a sense of individuality, rather than slavishly creating a collection around one silhouette or a single theme. In 2004 he celebrated his fiftieth fashion show with a dinner in Paris where models walked along dining tables wearing his spring/summer 2005 collection; the anniversary was also marked with the publication of a book, Dries Van Noten 01-50. He now has three stores and around 500 outlets worldwide, and continues to live and work in his hometown of Antwerp.

SUSIE RUSHTON

"I aim to create fashion that is neutral in such a way that each person can add his or her own personality to it"

PORTRAIT BY PAUL WETHERELL

DRIES VAN NOTEN

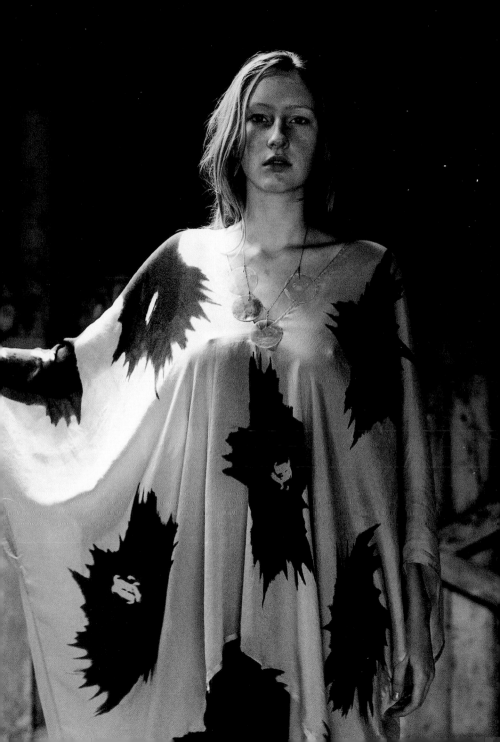

PHOTOGRAPHY BY MATT JONES, STYLING BY RUSHKA BERGMAN. OCTOBER 2000. MODEL: NADJA AUERMANN

Donatella Versace (born 1955) is a goddess of fashion. The female figurehead of one of the few remaining family-run fashion houses, she presides over seven brands under the Versace name. Her flamboyant, party-girl image has become synonymous with Versace itself. Gianni (born 1946) and Donatella grew up in Reggio Calabria, southern Italy. While her much older brother moved to Milan to seek his fashion fortune, Donatella studied for a degree in languages at the University of Florence. While there, her brother's career took off. After working for Callaghan and Genny, he set up his solo label in 1978. Suggesting the family's love for bright colours, body-hugging shapes and a large dose of glamour, it was a great success. He called on his younger sister to help develop the brand. The two worked together for much of the '80s and '90s, with Donatella concentrating on the sumptuous advertising images for which Versace is known to this day. She also set up the children's line, Young Versace, in 1993 and worked as head designer on the diffusion label, Versus. When Gianni was tragically killed in 1996, his sister became chief designer and inherited a somewhat daunting legacy. She met the challenge. Versace was brought into the 21st century by fusing Gianni's very Italian glamour with Donatella's own rock'n'roll instincts. Versace is continually in the public eye, not least because of its – and Donatella's – famous friends. Jon Bon Jovi, Courtney Love and Elizabeth Hurley are all devoted Versace fans. Madonna even posed as a sexy secretary in Versace's spring/summer 2005 ad campaign. Donatella is also responsible for extending the brand's range, setting up both a cosmetics line and Palazzo Versace, the first six-star Versace hotel, which opened on the Gold Coast of Australia in 2000.

LAUREN COCHRANE

"I am always driven to push forward, searching for what is modern. That is what motivates me"

DONATELLA VERSACE / PORTRAIT COURTESY OF DONATELLA VERSACE

VERSACE

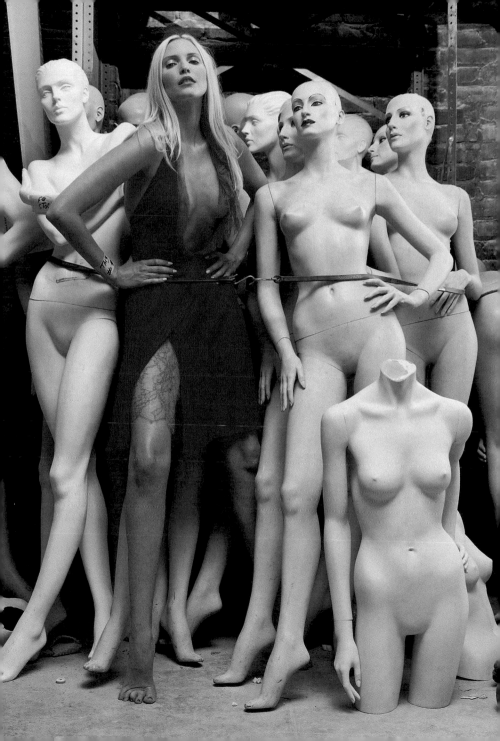

PHOTOGRAPHY BY RICHARD BURBRIDGE, STYLING BY EDWARD ENNINFUL. MARCH 2001. MODEL: STELLA TENNANT

Inseparable since they met whilst studying at Arnhem's Fashion Academy, Dutch duo Viktor Horsting and Rolf Snoeren (both born 1969) decided to join forces after graduating in 1992. Their first feat was winning three awards at the 1993 Hyères Festival with a collection that already betrayed their preferences for sculptural, experimental clothes. Soon afterwards, they joined the ranks of Le Cri Néerlandais, a loose collective of like-minded young designers from Holland who organised two shows in Paris. However, once Le Cri disbanded, Viktor & Rolf continued to produce collections, including one in 1996 called 'Viktor & Rolf On Strike' that decried the lack of interest in their work from press and buyers. Refusing to give up, the duo created a toy-like miniature fashion show and a fake perfume bottle with an accompanying ad campaign. These artefacts, presented in the Amsterdam art gallery Torch in 1996, established them as upstart designers with an unconventional agenda. But what really launched their careers was their introduction to Paris couture in 1998, where Viktor & Rolf stunned ever-growing audiences with their highly innovative creations based on exaggerated volumes and shapes. To everyone's surprise and delight, the duo have managed to translate their earlier spectacular couture designs into wearable yet ground-breaking prêt-à-porter pieces, showing their first ready-to-wear collection for autumn/winter 2000. Clinging to a love of ribbons and perfectly-cut smoking suits, Viktor & Rolf shows have become a must-see on the Paris prêt-à-porter schedule, and in 2004 they launched their first fragrance, Flowerbomb. They continue to live and work in Amsterdam. JAMIE HUCKBODY

"The illusion that next time it might be perfect keeps us going"

VIKTOR HORSTING AND ROLF SNOEREN
PORTRAIT BY ANUSCHKA BLOMMERS AND NIELS SCHUMM

VIKTOR & ROLF

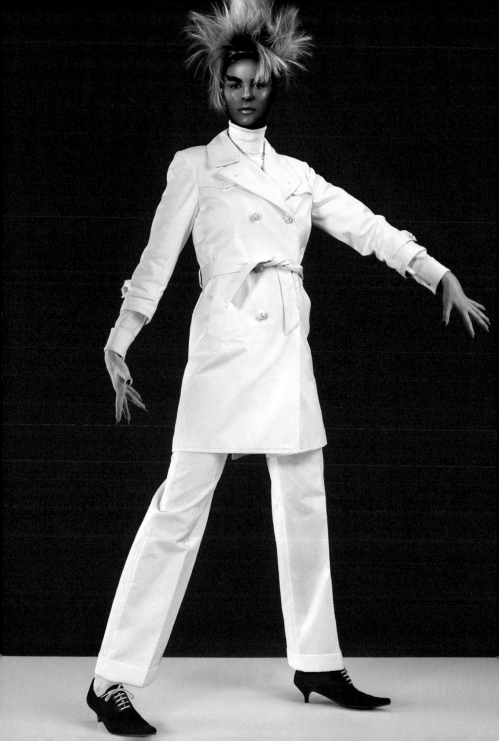

Junya Watanabe (born Tokyo, 1961) is the much-fêted protégé of Rei Kawakubo. Graduating from Bunka Fashion College in 1984, he immediately joined Comme des Garçons as a pattern-cutter. By 1987 he was designing their Tricot line. He presented his first solo collection in 1992 at the Tokyo collections; a year later, he showed at Paris Fashion Week. (Although designing under his own name, he is still employed by Comme des Garçons, who fund and produce the collections.) Despite an obvious debt to Rei Kawakubo in his work, Watanabe still stands apart from his mentor and friend with a vision that is indisputably his own. He has often used technical or functional fabrics, creating clothes that still retain a sense of calm and femininity. This was displayed most explicitly at his autumn/winter 1999 show, where the catwalk was under a constant shower of water: rain seemed to splash off the outfits, which were created in fabric by the Japanese company Toray, who develop materials for extreme conditions. Despite the wealth of creativity on display, Watanabe's clothes were a response to more fundamental issues: a practical answer to conditions and lifestyles. In contrast to this, Watanabe's designs are also an exercise in sensitivity and, through his remarkably complex pattern-cutting, his sculptural clothing presents a virtually unrivalled delicacy. In 2001, Watanabe presented his first menswear collection in Paris. Today, he is one of the most celebrated designers in Paris fashion. MARCUS ROSS

"I do what I do and those who sympathise with my work will wear it"

PORTRAIT BY TERRY JONES

JUNYA WATANABE

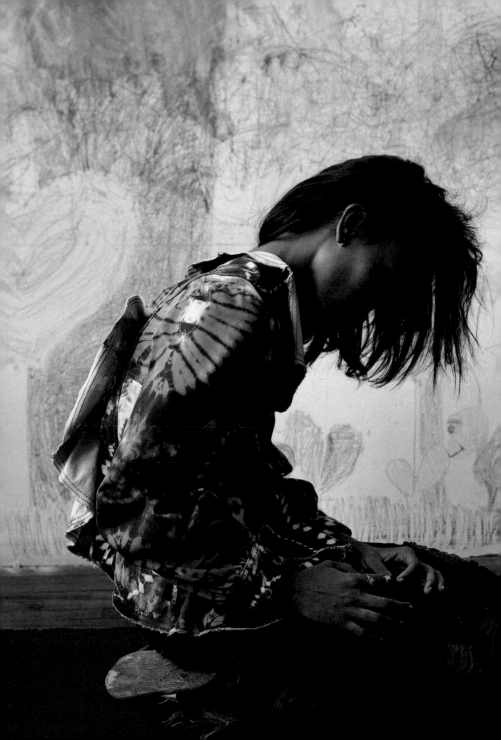

PHOTOGRAPHY BY KATE GARNER, STYLING BY STEPHANIE WOLF. SEPTEMBER 2002. MODEL: JT LEROY

Vivienne Westwood is a legend in her own lifetime, a designer who inspires many other designers and who makes clothes that delight her loyal customers. Born in Derbyshire in 1941, she first became a household name when, in partnership with Malcolm McLaren, she invented the punk uniform. Let It Rock, SEX, Seditionaries, Pirates, and Buffalo Girls were all early collections they created together at their shop in World's End, Chelsea. All became classics and served to challenge common preconceptions of what fashion could be. Since severing business ties with McLaren, Westwood has gone on to become one of the industry's most revered figures. She has achieved all this without any formal training. In the '80s she was hailed by Women's Wear Daily as one of the six most influential designers of all time, and in 2004 the Victoria & Albert Museum launched a travelling retrospective exhibition defining her iconic status – the tour will last 7 years and visit Australia, China and the USA. There is an intellectual method to the madness of her creative energy. Historical references, techniques and fabrics are intrinsic to her approach to design. The results are unconventional and alluring. Her subversive shapes and constructions have consistently proved to be ahead of their time. Awarded an OBE 15 years after being arrested on the night of the Queen's Silver Jubilee, she has now become a part of the establishment she continues to oppose. Myriad awards have been conferred on her, including British Designer of the Year, twice. Today she shows her ready-to-wear women's collection in Paris and a menswear collection, MAN, in Milan. While the interest in vintage West-wood has never been more intense, her diffusion line Anglomania regularly references pieces from her earlier collections. Westwood also has three best-selling perfumes – Libertine, Boudoir and Anglomania – and has shops in countries all over the world, including Hong Kong, Japan and Italy. TERRY NEWMAN

"Power is sexy. I like the men and women that I dress to look important"

PORTRAIT BY KAYT JONES

VIVIENNE WESTWOOD

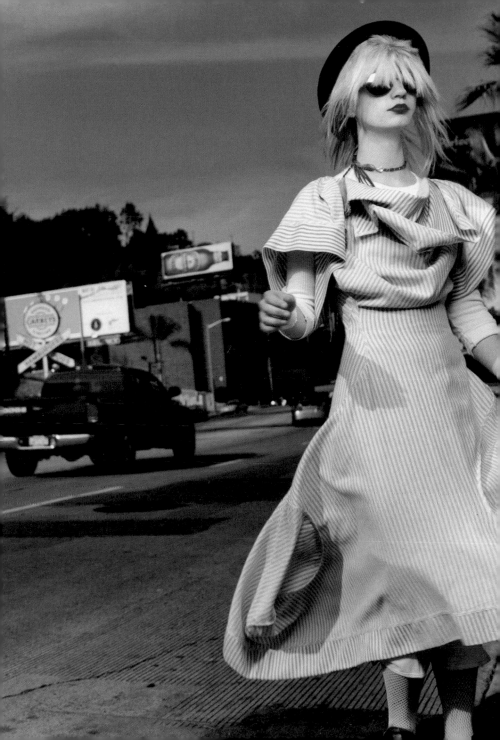

PHOTOGRAPHY BY TESH, STYLING BY EDWARD ENNINFUL. DECEMBER 2001/JANUARY 2002

Since graduating from Antwerp's Royal Academy back in 1998, Bernhard Willhelm has grown to become an icon and even an institution. Lamented by some, ridiculed by others, his voice is so strong, so extreme and so challenging. Like his mentor/tutor Walter Van Beirendonck, Willhelm's vision is unflappable and at times alienating to mass consumerism, but to challenge, confound and raise questions is surely Willhelm's point; at the end of the day, isn't fashion without a concept just clothes? Willhelm's catalogues can stand alongside art books. His Paris shows are performance pieces (a recent catwalk show ended with a parade of models bouncing on space hoppers) and his key pieces are instantly collectable artefacts. A German living in Antwerp, Willhelm references traditional folklore and fairytales, but not in a romantic, wistful way. His style is brash, playful and in your face: his day-glo dinosaur print has been a high point of his career so far. When Butt Magazine tore up the magazine rulebook in 2001, they chose Willhelm in tightie whities and a handle bar moustache to visually represent everything they stand for – fun fashion and fags. Proving he wasn't a one-trick show pony, in 2002, along with support from Tara Subkoff of Imitation of Christ and Sybilla, Willhelm enrolled as head designer at Roman couture brand Capucci. He instantly re-invigorated the house, giving edge, sporty energy and a refined touch to the label. With a newly realised shoe line and capsule collections for Yoox.com, Bernhard Willhelm is one of fashion's true gems. BEN REARDON

"The most important lesson
I've learned is, be kind"

PORTRAIT BY WILLY VANDERPERRE

BERNHARD WILLHELM

PHOTOGRAPHY BY MISCHA RICHTER, STYLING BY JAMES SLEAFORD. FEBRUARY 2002

Matthew Williamson uses colour in a way very few designers dare match. He routinely splashes ultra pinks, fluorescent yellows and acid greens with an energising flourish onto women's day and evening wear. This has become his signature style since the debut of his first collection, 'Electric Angels', in 1997 – a combination of kaleidoscopic bias-cut dresses and separates, sometimes embroidered and fused with a bohemian edge. Modelled by friends Jade Jagger, Kate Moss and Helena Christensen, it was a presentation that affirmed the London-based designer's influences: fame, glamour and India (Williamson's garments often read like a travel diary, tracing his love of exotic destinations). Celebrity was the all-important catalyst which made the fashion world sit up and pay attention to his work, but since that first collection, it's been the intricate detail, contemporary styling and sexy silhouettes that have kept the applause coming. Born in Chorlton, Manchester, in 1971, Matthew Williamson graduated from Central Saint Martins in 1994 and set up his own label in 1996 after spending two years as consultant at UK mass market chain Monsoon. 2002 saw the launch of a homewear range and a move to show his womenswear collections at New York Fashion Week. A first foray into perfume and home fragrance – a collaboration with perfumer and friend Lyn Harris – saw the creation of a limited edition perfume 'Incense'. Now selling to over 80 stores worldwide, the first Matthew Williamson flagship store opened in 2004 on London's Bruton Street, and there are plans for a New York store. TERRY NEWMAN

"Colour is the thing I'm best known for. If people pigeonhole me, so what? Long live the pink dress!"

PORTRAIT COURTESY OF MATTHEW WILLIAMSON

MATTHEW WILLIAMSON

PHOTOGRAPHY BY DUC LIAO, STYLING BY KANAKO B KOGA. MARCH 2002

Famed for his abstract silhouettes, flat shoes and unswerving loyalty to the colour black, Yohji Yamamoto is one of the most important and influential fashion designers working today. Uniquely, Yamamoto's clothing combines intellectual rigour with breathtaking romance; in his hands, stark and often extremely challenging modernity segues with references to Parisian haute couture. Born in Japan in 1943, Yamamoto was brought up by his seamstress mother, following his father's death in the Second World War. It was in an attempt to please his mother that he initially studied law at Tokyo's Keio University, later switching to fashion at the Bunka school, where he graduated in 1969. Following a trip to Paris and a period fitting customers at his mother's shop, Yamamoto established his own label in 1971, holding his first show in Tokyo in 1977. By the time he had made his Paris debut in 1981, along with his girlfriend at the time, Rei Kawakubo of Comme des Garçons, his label was already a commercial success back in Japan. Yamamoto sent out models wearing white make-up and asymmetric black clothing, and the establishment dubbed his look 'Hiroshima Chic'. However, a younger generation embraced Yamamoto, and both his womenswear and menswear – the latter shown in Paris for the first time in 1984 – became a status symbol for urban creative types. Despite his elite credentials, Yamamoto has expanded his business exponentially. He now has over 223 retail outlets worldwide, a groundbreaking collaboration with Adidas (Y-3), five fragrances, and casual collections, Y's For Women (established 1972) and Y's For Men (1971). He has been represented in numerous films, books and exhibitions; 'Juste des Vêtements, Yohji Yamamoto', his first major solo exhibition, was held in 2005 at the Musée de la Mode in Paris. Yamamoto is also a karate black belt and chief organiser of the Worldwide Karate Association. SUSIE RUSHTON

"You can say that designing is quite easy; the difficulty lies in finding a new way to explore beauty"

PORTRAIT BY CLAUDIO DELL'OLIO

YOHJI YAMAMOTO

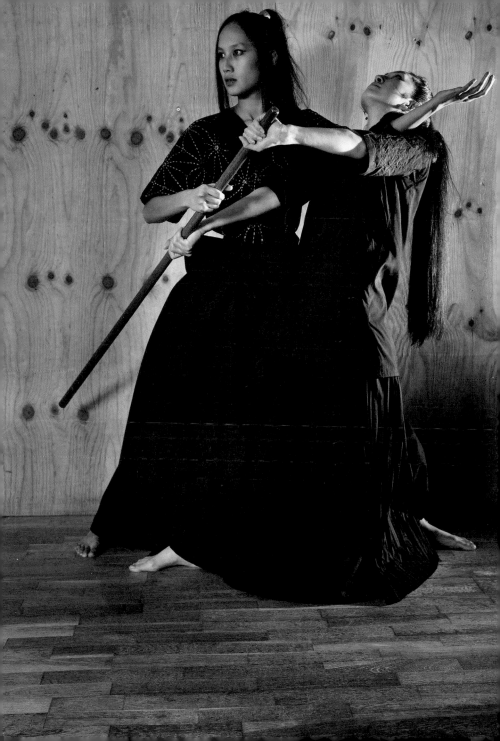

Fashion Now 2
Ed. Terry Jones & Susie
Rushton / Flexi-cover, 640 pp. /
€ 29.99 / $ 39.99 / £ 19.99 /
¥ 5,900

Fashion History
The Collection of the Kyoto
Costume Institute / Flexi-cover,
736 pp. / € 29.99 / $ 39.99 /
£ 19.99 / ¥ 5,900

**The Complete Costume
History**
Auguste Racinet / Hardcover,
636 pp. / € 150 / $ 200 /
£ 100 / ¥ 25,000

"These books are beautiful objects, well-designed and lucid."
— *Le Monde*, Paris, on the ICONS series

" Buy them all and add some pleasure to your life."

African Style
Ed. Angelika Taschen

Alchemy & Mysticism
Alexander Roob

All-American Ads 40ˢ
Ed. Jim Heimann

All-American Ads 50ˢ
Ed. Jim Heimann

All-American Ads 60ˢ
Ed. Jim Heimann

American Indian
Dr. Sonja Schierle

Angels
Gilles Néret

Architecture Now!
Ed. Philip Jodidio

Art Now
Eds. Burkhard Riemschneider,
Uta Grosenick

Atget's Paris
Ed. Hans Christian Adam

Berlin Style
Ed. Angelika Taschen

Cars of the 50s
Ed. Jim Heimann, Tony
Thacker

Cars of the 60s
Ed. Jim Heimann, Tony
Thacker

Cars of the 70s
Ed. Jim Heimann, Tony
Thacker

Chairs
Charlotte & Peter Fiell

Christmas
Ed. Jim Heimann, Steven Heller

Classic Rock Covers
Ed. Michael Ochs

Design Handbook
Charlotte & Peter Fiell

Design of the 20ᵗʰ Century
Charlotte & Peter Fiell

Design for the 21ˢᵗ Century
Charlotte & Peter Fiell

Devils
Gilles Néret

Digital Beauties
Ed. Julius Wiedemann

Robert Doisneau
Ed. Jean-Claude Gautrand

East German Design
Ralf Ulrich / Photos: Ernst Hedler

Egypt Style
Ed. Angelika Taschen

Encyclopaedia Anatomica
Ed. Museo La Specola
Florence

M.C. Escher

Fashion
Ed. The Kyoto Costume
Institute

Fashion Now!
Ed. Terry Jones, Susie Rushton

Fruit
Ed. George Brookshaw,
Uta Pellgrü-Gagel

HR Giger
HR Giger

Grand Tour
Harry Seidler

Graphic Design
Eds. Charlotte & Peter Fiell

Greece Style
Ed. Angelika Taschen

Halloween
Ed. Jim Heimann, Steven
Heller

Havana Style
Ed. Angelika Taschen

Homo Art
Gilles Néret

Hot Rods
Ed. Coco Shinomiya, Tony
Thacker

Hula
Ed. Jim Heimann

Indian Style
Ed. Angelika Taschen

India Bazaar
Samantha Harrison, Bari Kumar

Industrial Design
Charlotte & Peter Fiell

Japanese Beauties
Ed. Alex Gross

Krazy Kids' Food
Eds. Steve Roden,
Dan Goodsell

Las Vegas
Ed. Jim Heimann,
W. R. Wilkerson III

London Style
Ed. Angelika Taschen

Mexicana
Ed. Jim Heimann

Mexico Style
Ed. Angelika Taschen

Morocco Style
Ed. Angelika Taschen

New York Style
Ed. Angelika Taschen

Paris Style
Ed. Angelika Taschen

Penguin
Frans Lanting

20ᵗʰ Century Photography
Museum Ludwig Cologne

Photo Icons I
Hans-Michael Koetzle

Photo Icons II
Hans-Michael Koetzle

Pierre et Gilles
Eric Troncy

Provence Style
Ed. Angelika Taschen

Robots & Spaceships
Ed. Teruhisa Kitahara

Safari Style
Ed. Angelika Taschen

Seaside Style
Ed. Angelika Taschen

Albertus Seba. Butterflies
Irmgard Müsch

**Albertus Seba. Shells &
Corals**
Irmgard Müsch

Signs
Ed. Julius Wiedeman

South African Style
Ed. Angelika Taschen

Starck
Philippe Starck

Surfing
Ed. Jim Heimann

Sweden Style
Ed. Angelika Taschen

Sydney Style
Ed. Angelika Taschen

Tattoos
Ed. Henk Schiffmacher

Tiffany
Jacob Baal-Teshuva

Tiki Style
Sven Kirsten

Tuscany Style
Ed. Angelika Taschen

Valentines
Ed. Jim Heimann,
Steven Heller

Web Design: Best Studios
Ed. Julius Wiedemann

Web Design: Flash Sites
Ed. Julius Wiedemann

Web Design: Portfolios
Ed. Julius Wiedemann

**Women Artists
in the 20ᵗʰ and 21ˢᵗ Century**
Ed. Uta Grosenick